IMAGES
of America

POTOMAC

IMAGES
of America

POTOMAC

Judith Welles

ARCADIA
PUBLISHING

Published by Arcadia Publishing
Charleston, South Carolina

Printed in the United States of America

Library of Congress Control Number: 2019947288

For all general information, please contact Arcadia Publishing:
Telephone 843-853-2070
Fax 843-853-0044
E-mail sales@arcadiapublishing.com
For customer service and orders:
Toll-Free 1-888-313-2665

Visit us on the Internet at www.arcadiapublishing.com

This book is dedicated to Montgomery History, the historical society for Montgomery County, Maryland, and its donors and supporters, for preservation of photographs and other artifacts of the past so that we may remember as we move forward in time.

CONTENTS

ACKNOWLEDGMENTS

I am drawn to the history of Potomac from my research and writing about the nearby community of Cabin John. Capt. John Smith, who voyaged on the Potomac River in 1608, is likely the source of the name Captain John's Run, later Cabin John Creek, in Cabin John and also Captain John's Meetinghouse in Potomac. I wanted to explore the historical connections and go deeper into the history of the area.

Unless otherwise indicated, most of the photographs in the book come from Montgomery History, the Montgomery County historical society.

I thank executive director Matthew Logan for his encouragement and archivist Sarah Hedland for her resourceful help. I thank Arcadia Publishing editor Stacia Bannerman for her guidance. Many present and former residents, including Sylvia Bogley Biggar, Happy Bogley Galt, Mike Mitchell of Mitch & Bill's, Art Hyde, Elizabeth and Gary Altman, Margaret McBryde, Leonard Proctor, and Offutt family descendants Ralph Buglass and Anita Buglass Draper, provided important photographs and memories of people and events in Potomac. I thank William and Diana Conway for information on the Captain McDonald House they own and have so carefully restored. I give special thanks to Larry McBryde for his knowledge and photographs of Potomac farmland in the 1970s and Vicki Crawford who shared insights and historical photographs of The Potomac Hunt. Roy Sewall, Michael Mitchell, and Pat Michaels generously shared their amazing photographs. My photographs, as author, are marked JW. I also thank Michael Johnson and the special collections staff of the Enoch Pratt Free Library, volunteer Karen Gray with the Chesapeake & Ohio Canal National Historical Park, West Montgomery County Citizens Association president Ginny Barnes and board member Barbara Hoover, and the Maryland-National Capitol Park and Planning Commission (M-NCPPC) staff. In addition to my research, I was informed by past histories of the area including Margo McConihe's 1970 booklet "History of Potomac," Ann Paterson Harris's 1976 book *The Potomac Adventure*, and articles by Cissy Finley Grant and others of the *Potomac Almanac*. I thank my husband, Tim Shank, for his thoughtful comments and keen editing skills.

INTRODUCTION

Potomac, Maryland, grew from a crossroads. The intersection of two roads, set upon the ancient trails of Native Americans, enabled early settlers to reach and claim vast acres to farm and to build new industry on the banks of creeks and a cascading river. The roads led to the earliest towns, to the seat of the emerging Montgomery County, and to the capital of a new nation.

The word "Potomac" is from the Algonquian language and means "where something is brought." The Piscataway, who speak Algonquin, fished in the river, hunted through the woods and fields, and followed trails to trade with others. Various ways of spellings the word, including Patamack, Patowamack, Potowomack, and Potomack, are found in old records.

European settlers came in the 1600s. In 1608, Capt. John Smith voyaged the Chesapeake Bay and the "Patawomeck" River and stopped at many Native American villages. William Offutt, a Scotsman, was one of the most prominent settlers. He emigrated to the area in 1690 and married Mary Brock. They had 11 children, and members of the Offutt family continue to live throughout the area to the present day. Over time, William Offutt acquired some 3,000 acres, and by 1722, his landholdings were included in the colonial district called Potomac Hundred. In 1776, the property became part of Montgomery County, named for the Revolutionary War hero Richard Montgomery.

In the 1780s, George Washington traveled in the area with a vision of building a waterway for travel and transport to the west. He founded the Patowmack Company and began construction of a canal. While his venture did not succeed, John Quincy Adams broke ground for the Chesapeake & Ohio (C&O) Canal on July 4, 1828, and canal construction reached the crossroads area a year later. By 1850, the C&O Canal Company began operating between Cumberland, Maryland, and Georgetown, and area farmers began loading their products onto canalboats for quicker transport than taking wagons on the dirt roads.

The Chesapeake & Ohio Canal brought more people and more commerce, adding value to the properties near the canal and spurring growth of the area. Construction of the Washington Aqueduct, the first public water system for the nation's capital, also started from the Potomac River at Great Falls in 1853. New industry came at a time when tobacco farming had depleted the soil, some farm families had left, and farmers were transitioning to new crops and purposes. Farming wheat, corn, potatoes, and beans became a mainstay of the area, and horses and livestock began to be a new focus.

It was the extended Offutt family and the location of a general store called Offutts X Roads Market, housing a post office, that led to the early name of the area. Offutts Crossroads, labeled on early maps as Offutts X Roads, became a busy location at the intersection of two well-traveled roads, today Falls and River Roads. By the time of the Civil War, the community had two general stores and a blacksmith's shop. Confederate and Union soldiers marched through Offutts Crossroads to and from skirmishes and the battle at Antietam. Some Union soldiers from Pennsylvania found gold nuggets while camping near a creek in the woods and returned after the war in hopes of a gold rush. Remnants of gold mining that occurred between 1868 and 1940 can still be seen.

In 1880, the name of the area changed to Potomac. Capt. John McDonald, who fought in the Civil War and later became a congressman, is credited with the change. He lived in Offutts Crossroads and petitioned to change the name when postal officials were asking for brief names different from nearby locations. At the time, the county had several other "crossroads" communities. McDonald lived in a house built on the plantation site originally owned by Thomas Levi Offutt. His neighbors, the Offutts, Clagetts, and Magruders, owned acres of pastures and forested hills and had given some of their land for a church and schools.

In the early 1900s, Potomac became a center for horse farms, and by 1930, for foxhunts. The Potomac Hunt had its roots in The Washington Hunt organized by Sir Charles Vaughn, a British minister, in 1828, which moved to Tenleytown, where the name changed to the Dunblane Hunt. In 1892, the hunt reorganized as the Chevy Chase Hunt. When leadership died in the sinking of the *Titanic*, the hunt disbanded, and hounds were moved to the Washington Riding and Hunt Club. In the late 1920s, the hounds were moved to Charlie Carrico's Bradley Farm. Renamed The Potomac Hunt, it was recognized by the Masters of Foxhounds Association in 1931.

Potomac's rural farming community began to transition to suburban development in the 1950s. By 1980, one sign of the change from rural to suburban was The Potomac Hunt's move to more open land just beyond Potomac's border. Still, riding continues today, and some large homes with considerable and beautiful acreage have horse stables.

With 26 square miles and about 45,000 residents, Potomac is today a semirural suburban area with a 20854 zip code, located 15 miles from Washington, DC. While the community's boundaries have changed over the years, the census district for Potomac contains its historic areas. Many notables from the past and present, including political figures and celebrities, have made the area their home. In 1964, Montgomery County established land use guidelines that named the Potomac area as a "green wedge." Later, the area with winding, rustic roads received a semirural designation in the county's Potomac master plan. In the 1970s, Potomac Village saw its historic buildings morph into modern use as trendy shops and casual restaurants like the Happy Pickle. Residents who were teenagers at the time look back with nostalgia to their after-school gatherings with friends in the small town center. One of them, Larry McBryde, remarked, "Potomac was a grand adventure. It was horse farms and horse shows, romance, dating and breaking up, fast cars, trail rides and a mix of everything else. I loved those days in Potomac and never wanted to see it end." Many newer residents share the same affectionate view of the area today.

The Potomac River borders the community to the west with the majesty of Great Falls. The Chesapeake & Ohio Canal is now a national historical park with a main entrance in Potomac. Montgomery County's agricultural reserve provides a farmland conservation boundary to the north. Roads to the east and south take travelers and commuters to Rockville, Maryland, and to Washington, DC.

Potomac has a special feeling, a quiet area with rolling hills, wooded trails, and open fields. The national park provides scenic spaces to enjoy nature, hike, boat, and fish. Large estates with acreage, including a few restored farmhouses, remain near modern housing developments, public and private schools, diverse churches, and shopping.

Like Offutts Crossroads, Potomac Village is still at the historic intersection of two roads, a centrally located business hub. There are numerous banks, small shops and two large grocery stores, two gas stations, and a variety of restaurants. The chamber of commerce sponsors community events including the annual Potomac Day, which begins with a parade. Old Potomac meets new Potomac at restaurants like Old Angler's Inn and Normandie Farm. With a colorful and storied history, Potomac keeps its rural heritage in sight as it has evolved to a modern and growing suburban area.

One

OFFUTTS CROSSROADS TO POTOMAC

During the 17th century, many of the early settlers to the area came from Scotland, escaping political disfavor and turmoil in their country and turning the Maryland wilderness into farmland. The first Offutt land patent for 600 acres in 1714 was called Clewerwell, and soon, the family's holdings expanded to 3,000 acres with Clewerwald Enlarged, Outlett, and Bear Den. Some of the settlers planted tobacco, which was easy to grow in the rich soil. Tobacco even became a currency for a short time, valued at one penny a pound in crop notes, until crop value changed. But tobacco degraded the soil, and by 1800, farmers turned to planting wheat in addition to corn. Early roads, slightly wider than the trails of Native Americans, connected the Potomac area to Georgetown. New workers and families came to construct and operate the C&O Canal, to build the Washington Aqueduct, and to mine gold. Small wooden homes began to dot the area. It made common sense in 1875 to locate a post office and a market at the intersection of two roads, a central point where farmers and others could get needed supplies. Since the Offutt family owned vast acreage and a store, it also made sense to refer to the location as Offutts Crossroads, identified as Offutts X Roads on Martenet and Bond's 1865 map of Montgomery County, Maryland, and on G.M. Hopkins's 1879 Montgomery County map. To meet the needs of travelers passing through and those living in the countryside, businesses and services expanded to include a doctor, a blacksmith, and a tavern. More would continue to come to the scenic area of rolling hills, woodlands, and streams for the prospects of a comfortable life. By 1880, the population grew to 125, and the name changed to Potomac.

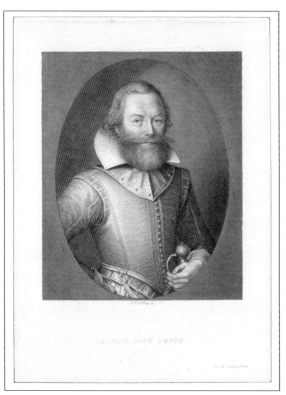

Capt. John Smith, explorer, voyaged the Chesapeake Bay and the "Patawomeck" River in 1608. He is thought to be the source of the name of Captain John's Meetinghouse, the Potomac area's first Protestant church, and of a nearby creek called Captain John's Run. The creek's name morphed over time to Cabin John. Rev. James Hunt took charge of Captain John's Meetinghouse in 1761, and the church flourished with an associated grammar school. The meetinghouse ceased to operate by 1830 after the decline of tobacco farming led many church members to leave the area. The tombstone below marks the grave of Reverend Hunt, who died in 1793. It remains in the cemetery of the Potomac Methodist Church, which was built on the site of the meetinghouse. (Left, courtesy of New York Public Library.)

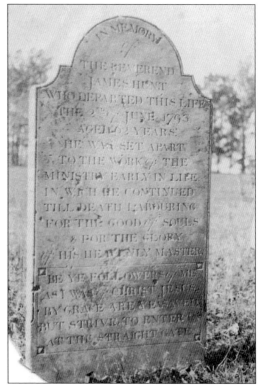

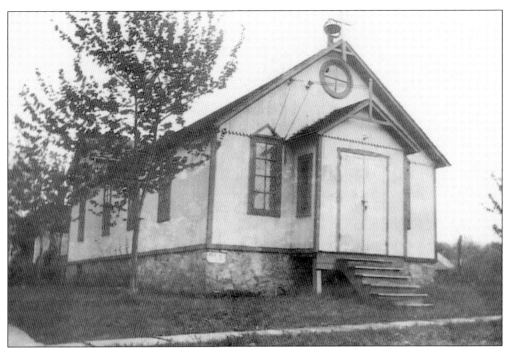

Potomac Chapel, above, which housed a Methodist congregation, replaced the meetinghouse in 1854 and was built on the original stone foundation that had been inscribed with the date 1716. In 1865, the Potomac Chapel School, one of the first free elementary schools in the county, was constructed adjacent to the church on property given by Oratio and Margaret Clagett, who are buried in the cemetery of the church. The present Potomac Methodist Church was erected on the site in 1969, pictured below. As Potomac's population grew in the mid-20th century, the congregation chose to demolish the one-story wood-frame church and build a two-story masonry church that seats 350 people in the nave, with balcony space for 100. A number of the stained-glass windows from the Potomac Chapel were retained and preserved.

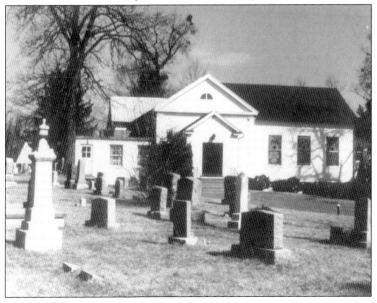

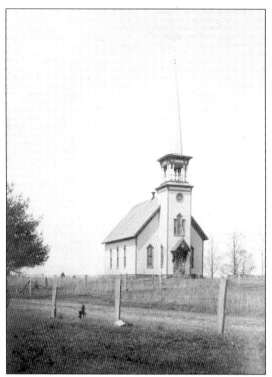

After Captain John's Meetinghouse closed, some of the remaining Presbyterian farmers sought another church. In 1874, Magruder, Offutt, and Moore families became founding members of the Hermon Presbyterian Church (left), which is still active today. Irish workers on the Chesapeake & Ohio Canal and the Washington Aqueduct came to worship at St. Gabriel's Church, built in 1890, shown below. Fr. John M. Barry, a priest who traveled from Tennalltown, the early name of Tenleytown near today's Tenley Circle in Washington, DC, gained permission to build a church that could seat 200 congregants. A major flood in 1924 ended canal operations, and when many of the workers who were members moved away, the church was abandoned. In 1933, a fire destroyed the building. A small cemetery remains with graves of some of the canal families. (Left, courtesy of Lilly Stone Lievsay.)

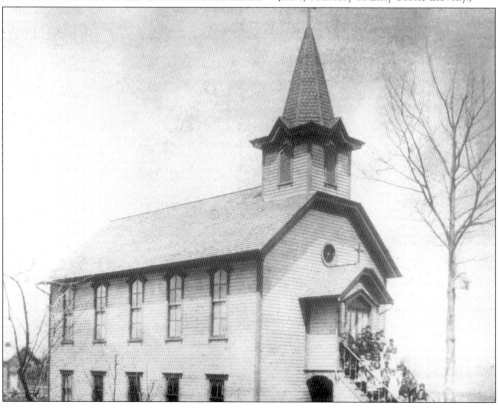

Offutts X Roads Market, a general store started by settler William Offutt's son Thomas, and the post office it housed led to the early name of the hamlet. Grandson Thomas Levi Offutt later took over management of the store. Customers such as Darius Clagett, William S. Offutt, and Capt. John McDonald were among many others who frequented the store, as recorded on pages from the store's ledger in 1875, pictured at right. Members of the Offutt family are buried at the Potomac Methodist Church cemetery. Graves of other early settlers of Offutts Crossroads are also found in the cemetery. (Below, courtesy of Ralph Buglass.)

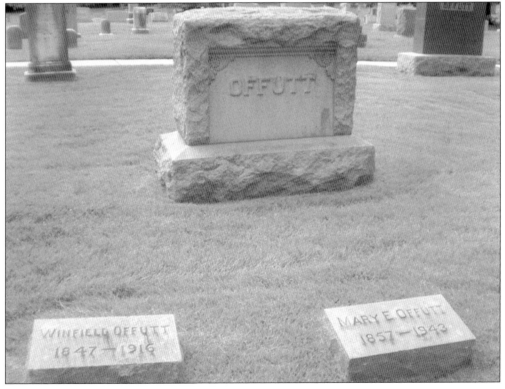

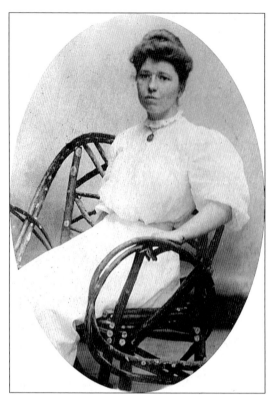

Winfield Offutt was the last owner of the last store named for the Offutt family in Potomac. In 1893, he sold Offutts X Roads Market and 53 acres surrounding it, and the family moved to Washington, DC. In 1912, his daughter Mabel, pictured at left, married Emil Busching when she was 29. In 1903, Offutt's son Roy (below) became a policeman in Washington, DC, when he was 23 years of age. (Both, Winfield Offutt family collection courtesy of Ralph Buglass and Anita Buglass Draper.)

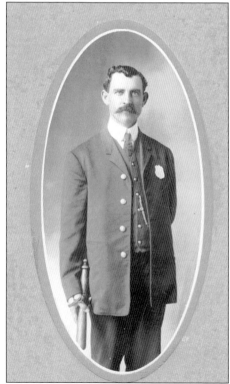

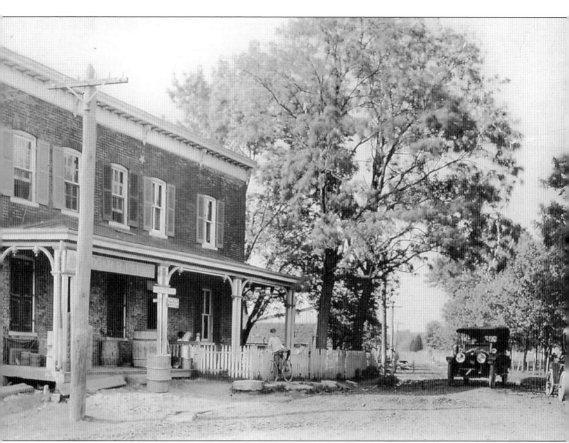

Thomas Perry partnered with Winfield Offutt in managing the market, but when that partnership soon dissolved, he started his own market across the road. Their competition continued for years. Built around 1878, Perry Store served as the Potomac Post Office in 1881 when Thomas Perry's wife, Marian, was appointed postmistress. Thomas Perry died in 1884 at the age of 39, and when this 1919 photograph was taken, his son Edgar Perry ran the store. The original building was divided into two units for the family's residence and the general store, which subsequent owners continued to use. Perry Store is the oldest commercial building still in use in Potomac Village.

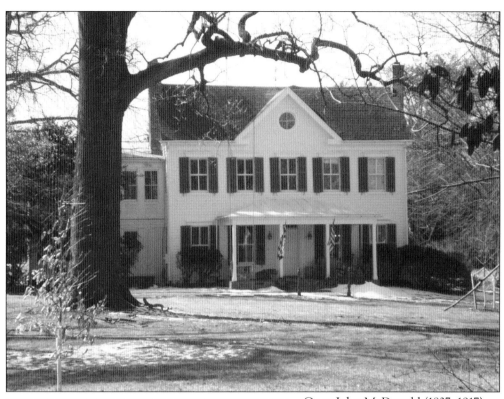

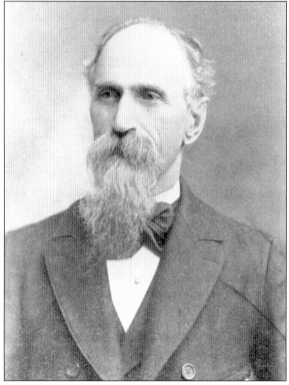

Capt. John McDonald (1837–1917), pictured at left, was a Civil War officer and later the first congressman elected from Potomac. He is credited with changing the area's name to Potomac in 1880. Sharing the post office's concern of multiple crossroads in the county, he petitioned for the change. His house, built on property originally owned by the Offutt family and called Cool Spring Level, is near the crossroad. From 1949 to 1972, Newbold Noyes, co-owner and editor of the *Washington Star*, and his wife owned the property and called it Trespassers W from *Winnie-the-Pooh*. Several owners, including the Noyes, have reported that ghosts occasionally make their presence known in the house. Bill and Diana Conway have maintained the farm's historic horse barn and restored the house to its early style. (Above, courtesy of Larry McBryde.)

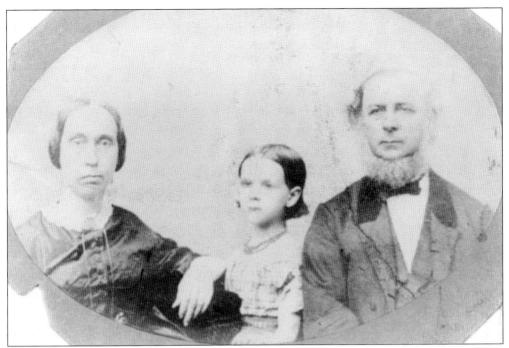

The Clagett family was among the original families to settle Offutts Crossroads. Thomas Clagett (1770–1860) farmed a tract of land referred to as Clagett's Folly and Addison's Park. At the time of his death, he left over 800 acres to his heirs. His son Oratio Clagett (1807–1871) is shown above with his wife, Margaret, and a daughter around 1862. They had 11 children. Oratio and Margaret Clagett donated a piece of their land for construction of the Potomac Chapel School. They are buried in the cemetery of the Potomac Methodist Church, below. (JW.)

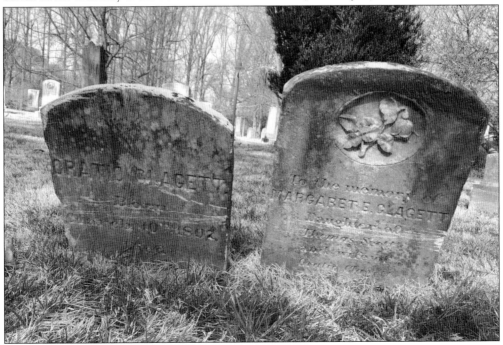

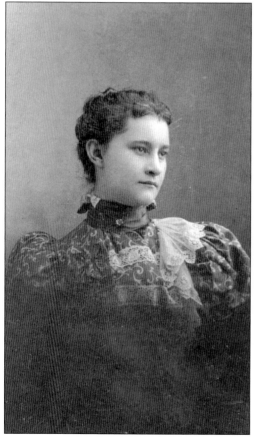

In 1810, Thomas Clagett's son Henry Clagett built a house in the Federal style, evidence of the family's prominence. Over the years, the Clagett house had several owners, including, in 1913, George G. Bradley, who was married to Katherine McDonald, the daughter of Capt. John McDonald. The house, remodeled with a brick addition in 1937, became part of the Harker School (above) and is now part of the St. Andrews Episcopal School. Another member of the Clagett family, Marguerite, is pictured at left when she was 19 in 1897. She was Oratio Clagett's niece, his brother Darius Clagett's daughter.

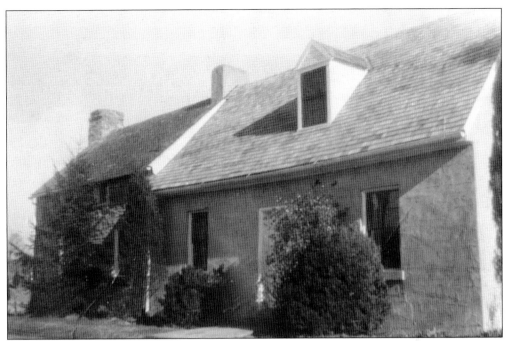

The Magruders were an early and extended family in Offutts Crossroads. The Joseph Magruder house, pictured above, exists today with the date August 14, 1787, on an exterior wall. Magruder (1742–1793) built the house section on the right and had a 400-acre tobacco plantation, which was supported by up to 13 slaves. In 1777, he was commissioned a captain in the Revolutionary militia. Another early resident, Dr. Cephas Willett, built a house around 1870 on four acres in Offutts Crossroads for $225. He sold it in 1883 for $1,550 to Matthew O'Brien, a blacksmith. The ledger from Offutts X Roads Market notes that Dr. Willett once bought a broom, sack of flour, and a box of collars. The house is the oldest dwelling in Potomac Village. (Below, courtesy of Larry McBryde.)

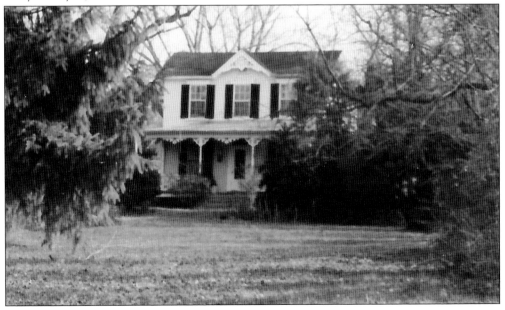

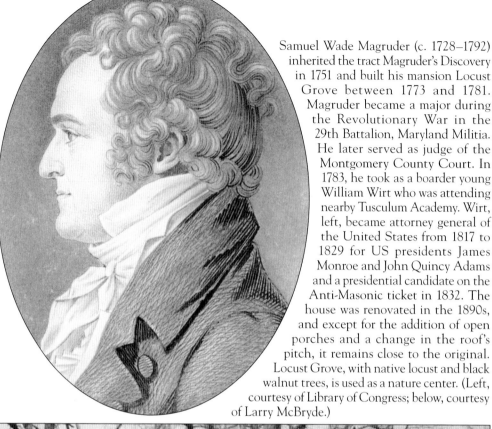

Samuel Wade Magruder (c. 1728–1792) inherited the tract Magruder's Discovery in 1751 and built his mansion Locust Grove between 1773 and 1781. Magruder became a major during the Revolutionary War in the 29th Battalion, Maryland Militia. He later served as judge of the Montgomery County Court. In 1783, he took as a boarder young William Wirt who was attending nearby Tusculum Academy. Wirt, left, became attorney general of the United States from 1817 to 1829 for US presidents James Monroe and John Quincy Adams and a presidential candidate on the Anti-Masonic ticket in 1832. The house was renovated in the 1890s, and except for the addition of open porches and a change in the roof's pitch, it remains close to the original. Locust Grove, with native locust and black walnut trees, is used as a nature center. (Left, courtesy of Library of Congress; below, courtesy of Larry McBryde.)

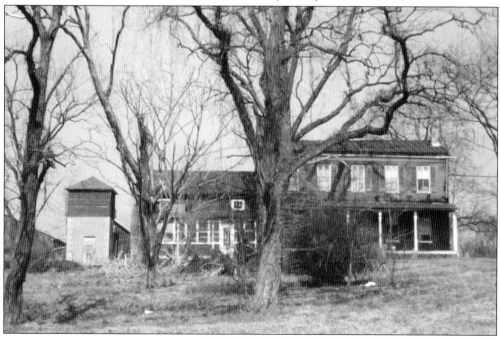

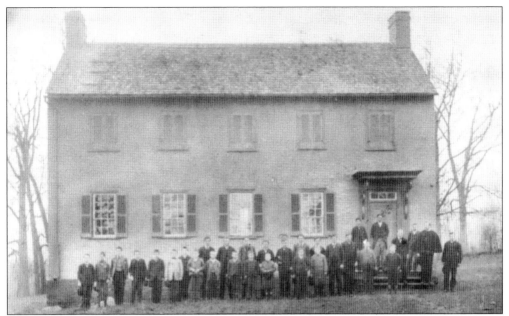

Rev. James Hunt, an educator and a theologian, established Tusculum Academy in 1783, a secondary school for young men. After Hunt died in 1793, no similar school for young men followed until Rockville Academy in 1806, shown above in 1880. Three of the first free public schools were in the Potomac area in 1865: Potomac Chapel School adjacent to the Methodist church, Harris School between Offutts Crossroads and Great Falls, and Great Falls School. Salaries for teachers were $85 per quarter for a minimum of 15 students with $1 or $2 added for each student up to 60. None of the schools exist today. The one-room Seneca School on River Road, pictured below, is a private school constructed of Seneca red sandstone and established by a mill owner around 1865 because there were no public schools nearby.

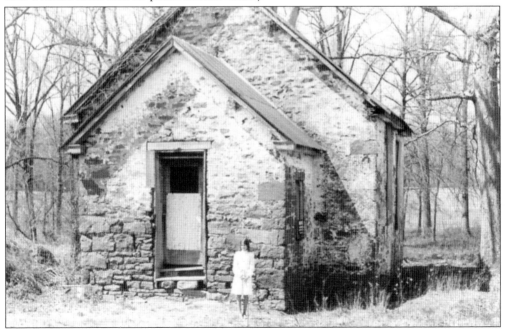

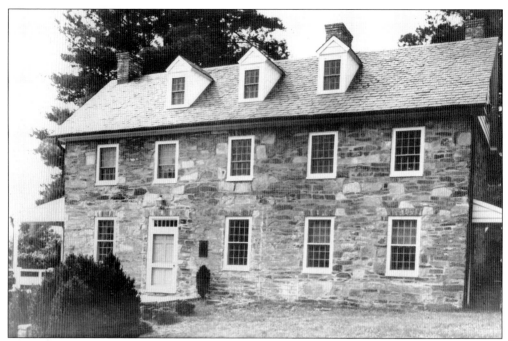

Samuel Brewer Magruder built his stone house in 1767 on part of Ninian Magruder's tract of land named Honesty. The extended Magruder family figured importantly in the American Revolution. An inscription on the house "SBRM 1767" stands for his initials and that of his wife, Rebecca. Stoneyhurst, pictured above in 1975, was named by later owner Lilly Moore Stone in 1909 and sits hidden by trees on a bluff above River Road. Nearby is Magruder's Blacksmith Shop (below), built by Ninian Magruder around 1751 with uncoursed rubblestone. It is the oldest standing structure in the Potomac area today. Ninian Magruder, a blacksmith, served the needs of merchants and travelers by fixing wagons and shodding horses. His initials are carved on the chimney. (Both, courtesy of M-NCPPC.)

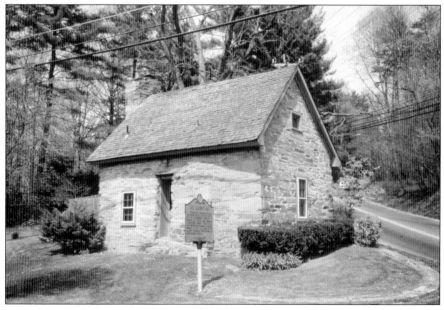

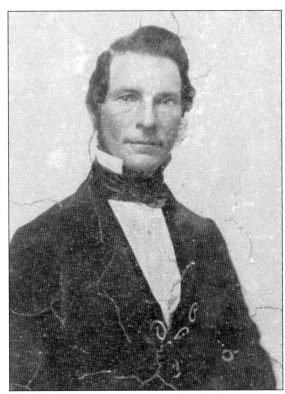

John Duke of Wellington Moore, known as J.D.W., came to the area in 1858 with his bride, Sarah Coltman Moore. They named their farmhouse Glenmore, built in 1864. With neighboring Saunders and Dowling farm families, J.D.W. Moore helped build the one-room Friendship School that his daughter Lilly attended, and was a founding member of the Hermon Presbyterian Church. He and his wife are pictured in 1858. The Moores owned 200 acres along what is now Persimmon Tree Road, across from hundreds of acres owned by members of the Stone family. In 1892, Lilly Moore married Frank Stone; she later owned Stoneyhurst farm and started the Stonehurst Quarry. (Both, courtesy of Lilly Stone Lievsay.)

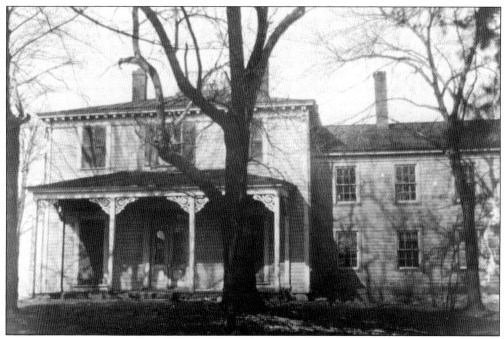

The Moores' home Glenmore, seen above in 1892, exists today with some exterior changes including stone veneer from Stoneyhurst Quarry, a library wing on the left, and a portico that replaced the wide porch. When J.D.W. Moore and his wife died, their daughter Lilly Moore Stone inherited the home and the acreage surrounding it. She gained prominence from owning the substantial properties of Stoneyhurst and Glenmore and as a successful businesswoman operating a quarry. She also contributed to the community by founding the historical society for Montgomery County, now Montgomery History. (Both, courtesy of Lilly Stone Lievsay.)

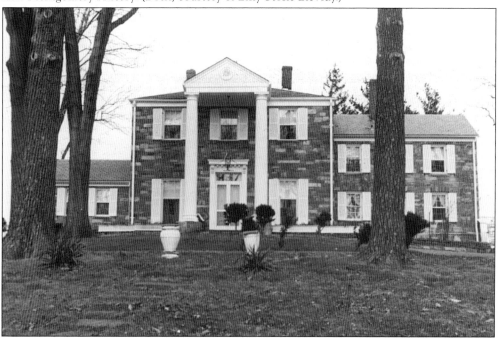

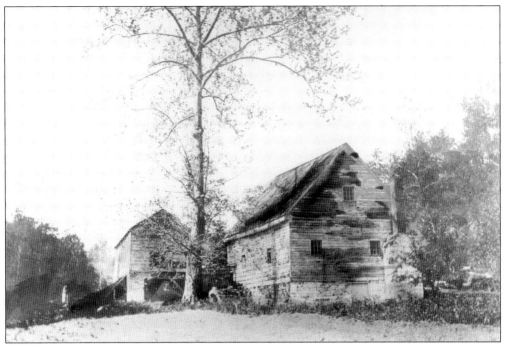

Water-powered mills were used to grind corn and wheat into meal and flour and saw lumber and cut stone for building homes. By 1800, there were 44 mills operating in Montgomery County, with several of them in Offutts Crossroads. Around 1850, Orndorff's Mill was on Cabin John Creek near Locust Grove and was later called Bells Mill, shown above. Glen Mill, below, was built by Tom Peters around 1870 and operated until about 1923. It burned around 1950. An "Old Paper Mill" shown on Hopkins's 1879 map was on Cabin John Creek near River Road.

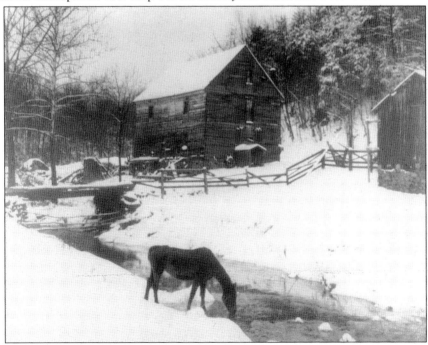

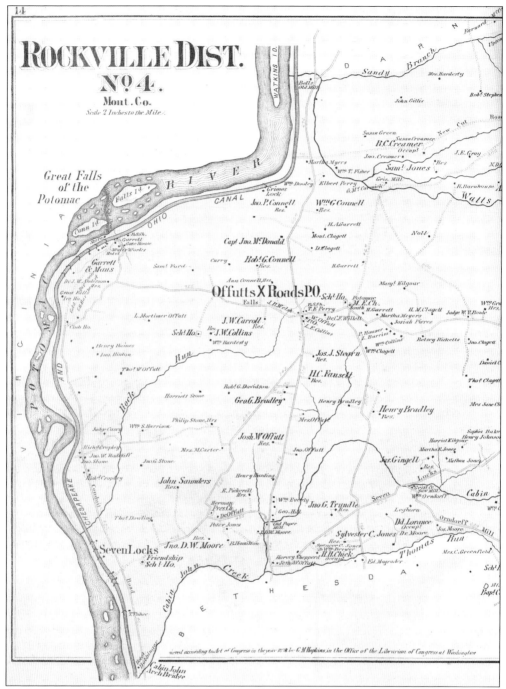

G.M. Hopkins's 1879 map captures the location of major landholders, stores, and roads of Offutts Crossroads on the cusp of it being renamed Potomac. The post office stood at the crossroads intersection where Falls Road crosses an unmarked River Road. The residents of the hamlet that was to become Potomac Village included Edgar Perry, Winfield Offutt, Dr. Cephas Willett, members of the Clagett and Collins families, and Capt. John McDonald. A school is noted next to the Methodist church. Farms owned by the Moore and Stone families are also marked.

Two

RIVER, CANAL, AND ROADS

Potomac's location has been ideal for transportation to major destinations to the north, south, east, and west. The Potomac River and the Chesapeake & Ohio Canal, now a scenic national park, border Potomac. The wild river churns in rushing torrents over bedrock and gorges formed millions of years ago to its greatest drop at Great Falls, a thrilling sight. The water route to the west that George Washington had envisioned took shape in the Chesapeake & Ohio Canal, which reached Offutts Crossroads in 1829. By 1850, the C&O Canal Company began operating from Cumberland, Maryland, to Georgetown in the District of Columbia, and Potomac farmers transported grain and other products on the canalboats. Even presidents traveled to the river and canal in Potomac for recreation. Grover Cleveland liked to fish for bass. Theodore Roosevelt enjoyed chauffeur-driven rides to Great Falls, and hiked and fished at Widewater, where the canal widened to a small lake. According to a resident, Pres. Woodrow and First Lady Edith Wilson rode in a long, black car, similar to a Pierce Arrow, to visit Great Falls. The Potomac River, starting at Great Falls, became the source of public drinking water for Washington, DC. The US Army Corps of Engineers, led by Col. Montgomery Meigs, constructed the Washington Aqueduct, laying conduit pipes nine feet in diameter underneath the berm side of the C&O Canal to Conduit Road, later named MacArthur Boulevard. The confluence of roads like Conduit Road, Falls Road, and River Road became major routes for travelers and, during the Civil War, for armies of the South and the North. In Maryland, residents were divided in sympathy for the Union and the Confederacy, turning neighbors and even families against one another. In 1860, the county population of 18,322 included some 5,500 slaves and 1,500 freed slaves. Confederate soldiers crossed the river and canal and marched through Offutts Crossroads. They skirmished at Great Falls, where Union troops were stationed to guard against Confederate crossings, and retreated through farmland from the Battle of Antietam. Some Union soldiers saw the glint of gold in a creek near the canal and returned after the war in a gold rush.

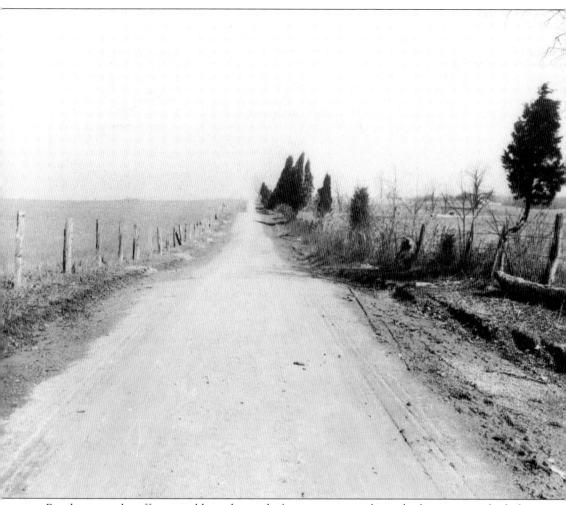

Roads were risky affairs, muddy and rutted after storms or with crushed stones on which farm wagons bumped slowly along. River Road was a main dirt road, formed from a well-worn trail, and was later used by farmers to transport tobacco to the port of Georgetown. The first paved road was part of River Road from the area that is now an intersection with Bradley Boulevard to Falls Road. The part of River Road toward Washington was not paved until the 1930s. Falls Road, pictured above in 1909 when the county had built three miles of the road, was originally called Post Road. In 1914, Falls Road was widened and completed as a dirt road from the crossroads to Rockville, a distance of six miles, which still took an hour by horse and buggy. The road was finally paved in 1930.

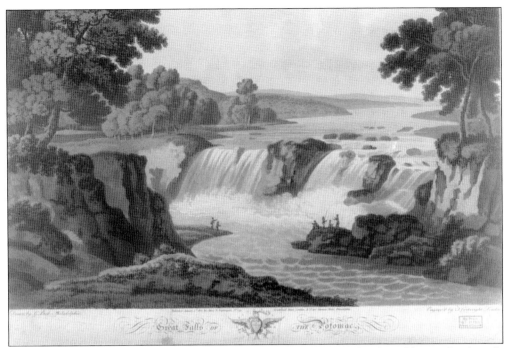

The Potomac River drops 76 feet over the distance of less than a mile of a wild cascade of rapids and waterfalls aptly named Great Falls. The scene has awed spectators for centuries, as depicted in the 1802 drawing above by George Beck. The river churns through narrow chutes and over huge rocks to create a gorge below the falls. Only 15 miles from the nation's capital, Great Falls has been popular not only for visitors, as pictured below in 1864, but also for those who live nearby. (Both, courtesy of Library of Congress.)

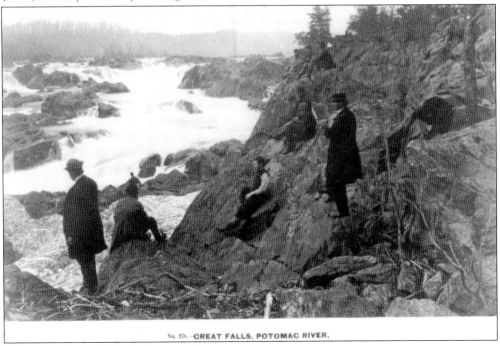

No. 258.—GREAT FALLS, POTOMAC RIVER.

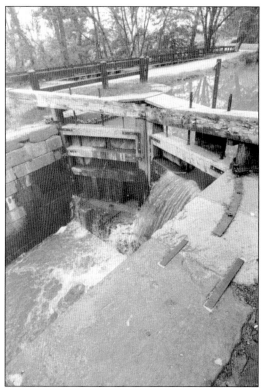

Along the 184.5 miles of the Chesapeake & Ohio Canal were 74 locks to raise or lower boats an average of eight feet at each lock to manage the elevation between Georgetown and Cumberland. Gates let water in or out of locks to float the boats higher or lower to reach the necessary level to enter and continue along the canal. Lock tenders lived in lockhouses beside the canal to open the locks day or night as canalboats approached. Potomac farmers knew the lock tenders at Swains, Pennyfield, and Violettes Locks well, and their families were friends. They relied on the lock tenders, pictured below, to assure they could transport their farm products on the canalboats heading to Georgetown.

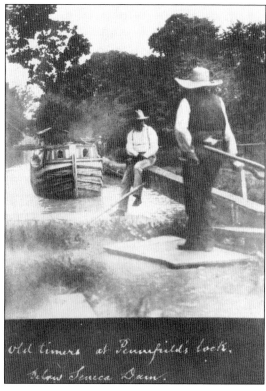

Old timers at Pennyfield's lock. below Seneca Dam.

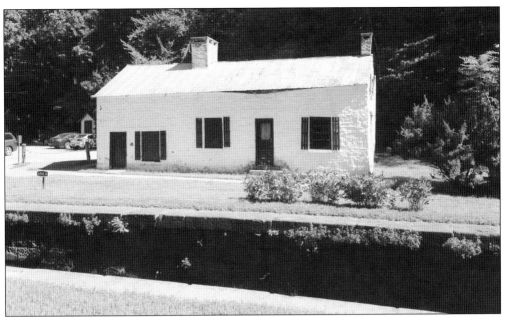

Swain family members worked on construction of the canal and as boatmen and lock tenders at several locks. Swains Lock was named for lock tender Jesse Swain whose family lived in the lockhouse since 1910. Jessie Swain also drove a covered wagon pulled by four mules that was the first school bus in Potomac. According to *Potomac Adventure*, the wagon was exchanged for a truck in 1918, which went so slowly up the steep hills that children sometimes ran alongside. After the C&O Canal Company stopped operating, Swain descendants opened the lock for pleasure boats and started a concession renting canoes until 2006. Swains lockhouse at Lock No. 21, above, and Pennyfield lockhouse at Lock No. 22 are among seven restored lockhouses managed by the C&O Canal Trust for overnight guests visiting the Chesapeake & Ohio Canal National Historical Park. (Above, courtesy of C&O Canal Trust.)

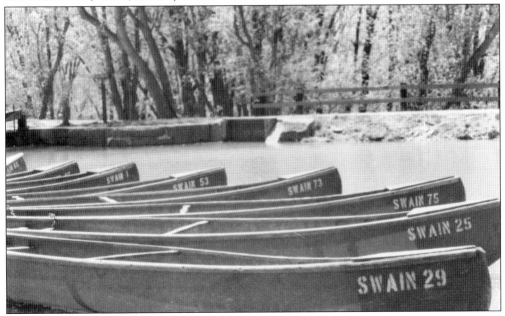

Pennyfield Lock No. 22 was a favored spot for Pres. Grover Cleveland to fish for bass. In the 1870s, Cleveland, who grew up on the Erie Canal, would regularly visit Pennyfield as a restful retreat. He was well-known by the canal boatmen who came through the lock. The lock tender George Pennyfield and his wife, Martha, ran a boardinghouse, above, known as Pennyfield's Inn where Cleveland stayed when he went on fishing excursions. Cleveland returned the favor by inviting Pennyfield to visit the White House, where he was warmly received. The frame inn, built on the berm side of the canal in 1879, fell into disrepair and was demolished in 2009. The lockhouse at Pennyfield Lock, below, was rehabilitated for overnight stays through the C&O Canal Trust.

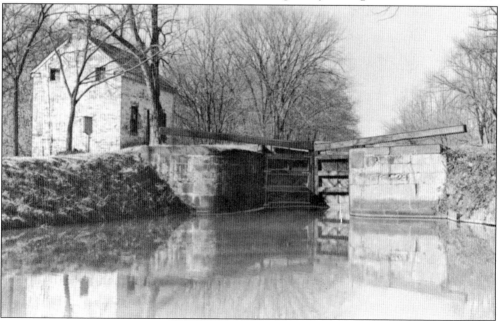

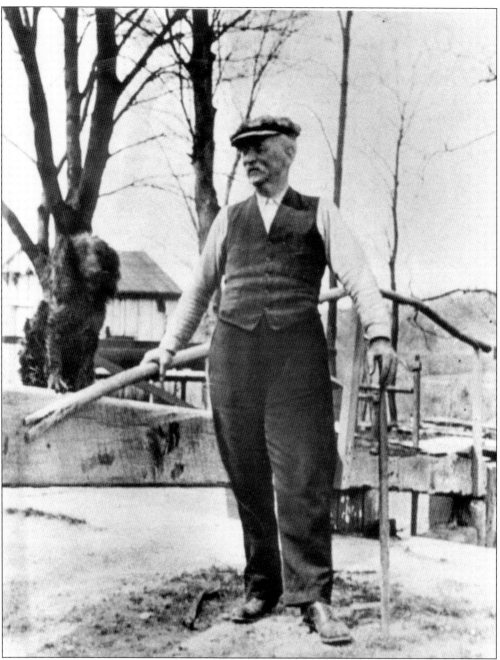

Violettes Lock No. 23 was tended by Alfred L. Violette, shown here in 1900 with his dog Rags. Violettes Lock was close to Dam No. 1, which fed the canal from the Potomac River, and Violette complained that the roar of the water made it hard for him to hear the shouts and horns of approaching boats. Before becoming a lock tender, Violette had worked at the Seneca stone cutting mill in 1890. Seneca red sandstone was used in the building of Lock No. 23. Ray Riley, the lock tender at Riley's Lock No. 24, sometimes stepped in to help open and close the lock when he saw Violette having trouble hearing the boats coming. Alfred Violette died in 1934 and is buried nearby at the Darnestown Presbyterian Church cemetery.

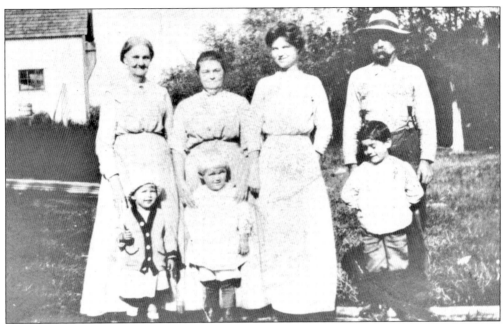

Alfred Violette is shown above with his family in 1910. When he became ill, his wife (second from left) took over the work and was the last lock tender at Lock No. 23. Boats could pass between the canal and the river through Lock No. 23 because river water was diverted from behind the dam to the canal. The lockhouse at Violettes Lock, seen in the rare photograph below, was a frame house close to the lock unlike the stone lockhouses at other earlier locks. It may have replaced a smaller original log lockhouse, but nothing remains of it, and the frame house also did not withstand the ravages of floods and time. A small community near Lock No. 23 was known as Rushville in the early 1800s, but the general area was called Seneca. (Below, courtesy of Chesapeake & Ohio Canal National Historical Park.)

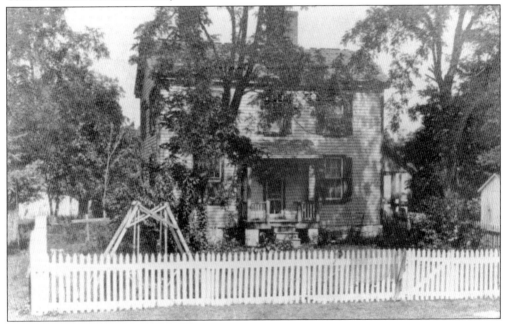

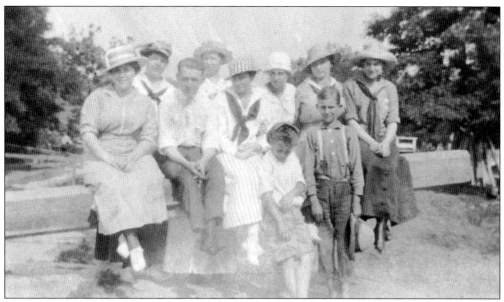

Visitors often walked on the canal towpath from Pennyfield to Violettes Locks. Pictured above are friends visiting Pennyfield Lock. Hatton Waters owned the canal barge *Alice Mae*, named for his daughter, seen on the left in the photograph below. The barge was the last boat built in Cumberland. Waters also had a warehouse next to the canal near Pennyfield Lock where he stored and transported grain from the farms. Alice and her friend Addie Snyder were dressed for a special occasion when they were photographed on the barge around 1915. The barge was returning from Georgetown in 1924 after delivering grain when the C&O Canal Company ceased operations. The canal water was drawn down, leaving just enough for the barge to get through Violettes Lock, where it stayed for several years.

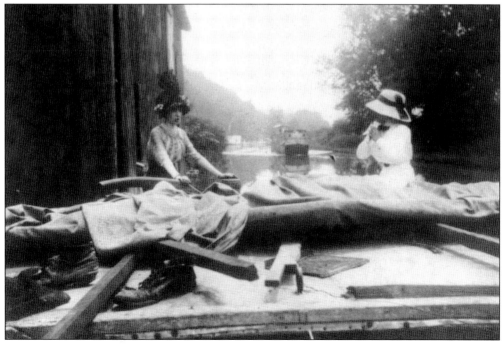

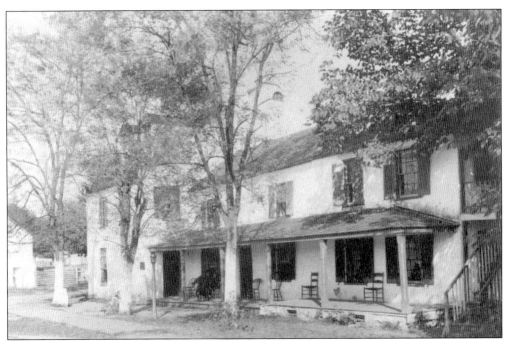

Great Falls Tavern was both the lockkeeper's home and an inn for travelers on the Chesapeake & Ohio Canal. The lockhouse was built around 1831, and W.W. Fenlon, the lockkeeper, suggested that the C&O Canal Company expand the building for travelers. For a time, the inn, shown above in 1889, was named Crommelin House after a man who managed to get Dutch loans for the company. It was later called Great Falls Tavern. For 25¢, overnight guests could reserve a bunk in the ladies' or the men's quarters on the second floor. The tavern now houses a visitor center for the national park. (Below, courtesy of Michael Mitchell, former chairman of the C&O Canal Trust.)

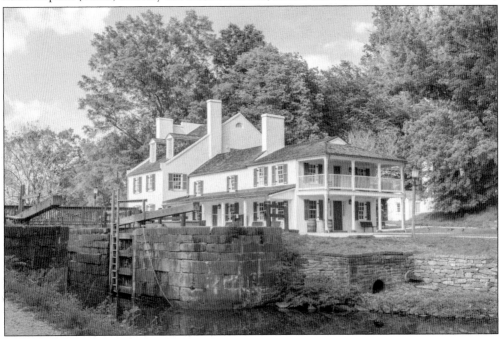

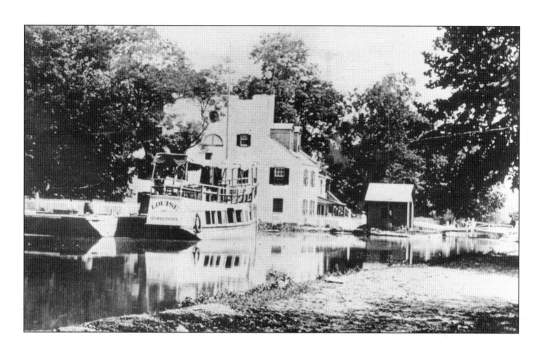

The steam-powered packet boat *Louise* carried visitors from Georgetown to Great Falls Tavern at the turn of the 20th century, pictured above. The *Louise* is also shown below carrying passengers through the Widewater section of the canal in Potomac on the way to the tavern. At the height of the C&O Canal Company operation, there were 500 mule-drawn boats and 17 steamboats. (Both, courtesy of Chesapeake & Ohio Canal National Historical Park.)

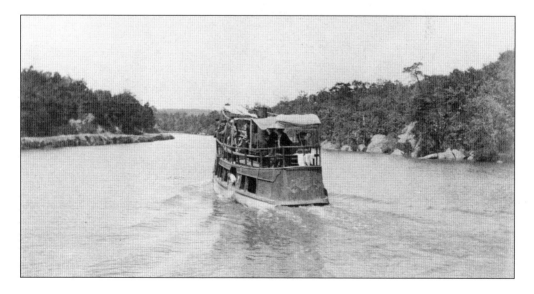

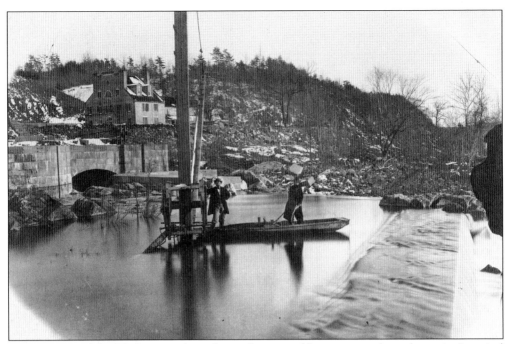

Construction of the Washington Aqueduct to bring a public water supply to the nation's capital began in 1853 on the Potomac River, as seen above, close to Great Falls Tavern. The plan was to divert water from the river to a brick conduit pipe nine feet in diameter that would be 12 miles long. Gravity and pumping stations would direct water through the conduit to reservoirs, where it could be pumped to the city's pipelines. Another view below shows the entrance to the conduit tunnel with the tavern above and a pulley for lifting stone. (Both, courtesy of Library of Congress.)

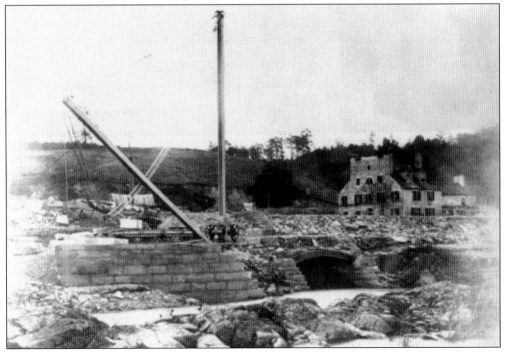

Supervised by Capt. Montgomery Meigs (right) of the US Army Corps of Engineers, the building of the brick-lined tunnel (below) for the conduit pipe brought Irish and German workers and families to the area. When the project was completed in 1863, area farmers began to use the smooth macadam cover of the conduit like a road, the first hard surface instead of dirt roads for their wagons. It was soon called Conduit Road, a name that stayed until World War II, when it was renamed MacArthur Boulevard. Meigs also designed Arlington National Cemetery and the Pension Building, now the National Building Museum, in Washington, DC. (Both, courtesy of Library of Congress.)

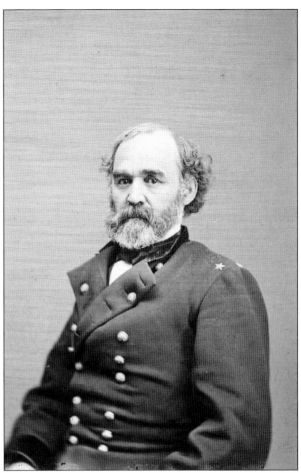

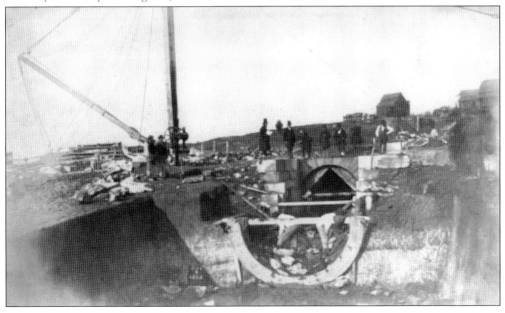

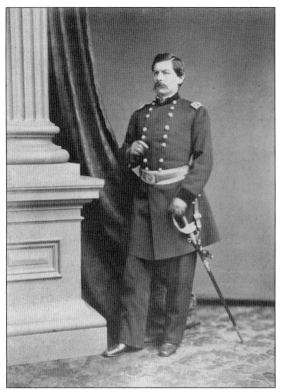

Many of the Union troops sent to occupy Montgomery County came through Offutts Crossroads in 1861 and 1862. On the way to the Battle of Antietam, a division that was part of the left wing of the army of General McClellan (left) advanced through the crossroads along River Road in September 1862. In late June 1863, two cavalry brigades of Maj. Gen. J.E.B. Stuart (below) crossed the Potomac at night at Rowser's Ford below Seneca. To stop the Union Army from using the canal to move supplies and troops, they damaged the canal where they crossed, jamming barges into locks and burning them. Then, they moved through Offutts Crossroads toward Rockville on the way to Gettysburg. (Both, courtesy of Library of Congress.)

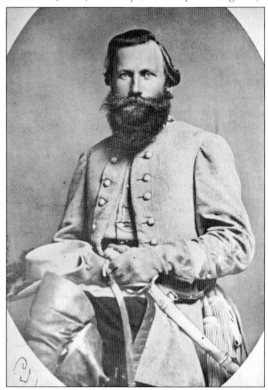

Union troops camped for the night at the crossroads before pursuing Maj. Gen. Jubal Early's troops, which had moved against Washington's defenses. Union wagons crossed the Union Arch Bridge, shown below, another engineering project of Montgomery Meigs, that carried the conduit pipes for the Washington Aqueduct. In 1863, the bridge was the longest single-arch stone bridge in the world. Today, it is called the Cabin John Bridge. (Both, courtesy of Library of Congress.)

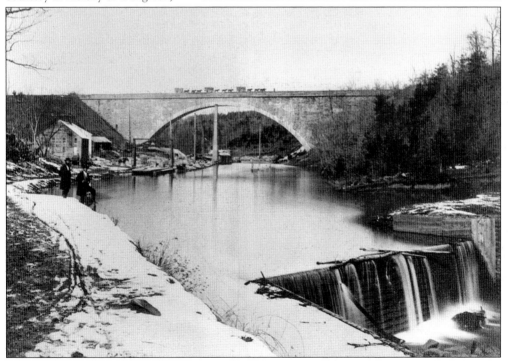

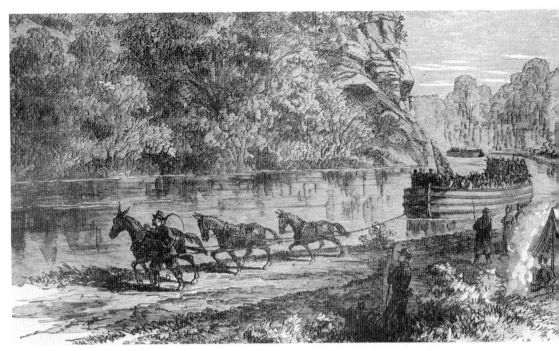

A Civil War View of the Canal, by Thomas Nast.

(Courtesy of the Enoch Pratt Free Library.)

With many places for Confederate troops to cross the Potomac River and skirmish with Union forces, the Chesapeake & Ohio Canal had frequent damage from the conflict. As the canal was a federal logistics route for transporting fuel, food, and occasionally troops and supplies, Confederate soldiers tried to disrupt operations of the canal throughout the Civil War. The Union Army, shown above traveling on a canalboat in an 1862 etching by Thomas Nast, were stationed at various points to protect the canal and prevent Confederate troops from crossing the Potomac River. (Courtesy of Enoch Pratt Free Library Maryland's State Library Resource Center.)

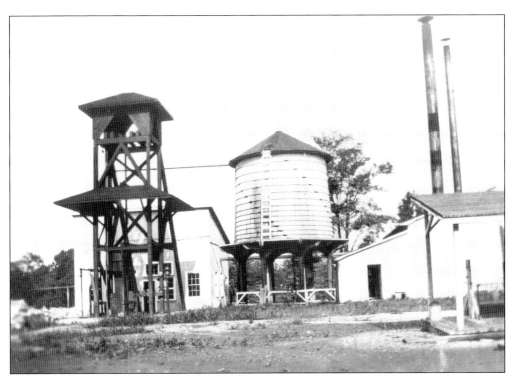

In 1861, Union soldiers in the 71st Pennsylvania Infantry encamped near Great Falls noticed yellow grains in the pans they were cleaning at a stream. Recalling the California gold rush, one vowed to return after the war. George Powell and John Stockton, who had served at Great Falls, opened the first gold mine in Maryland in 1865 in Potomac with Amos Griffiths and John Shyrock. They sent gold in 1867 to the US Mint in Philadelphia, which recorded 11 ounces. The Great Falls Gold Mine was abandoned in 1869, and a series of stops and starts began until the area was purchased by the Maryland Mine Company, which dug deeper shafts. The gold mine's water tank, shaft, and hoists are shown above around 1920, and a miner at a 100-foot shaft in 1919 is pictured at right. (Both, courtesy of Chesapeake & Ohio Canal National Historical Park.)

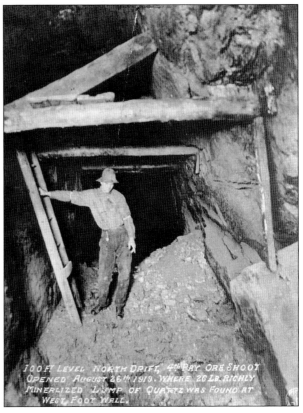

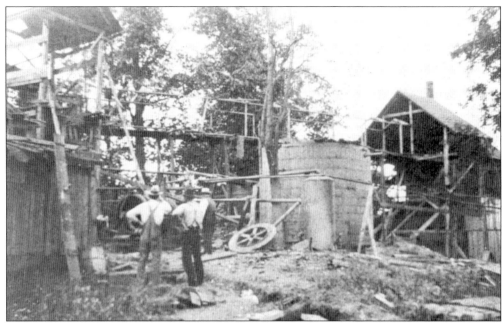

Mining operations at Great Falls moved ahead in the 1900s. But on June 15, 1906, a miner's lamp accidentally ignited some dynamite and caused a devastating fire, as shown in these photographs. The death of one of the miners led to stories of ghosts called Tommyknockers, with unaccountable noises reported near the mine at night. Mining halted until 1912, when repairs were completed. The Great Falls Mining Company then acquired over 2,200 acres, and prospecting started again. But the cost of exploration, trenching, and underground development proved too great, and the company was sold. The gold-bearing zone went from the Chesapeake & Ohio Canal at Widewater to about two miles north.

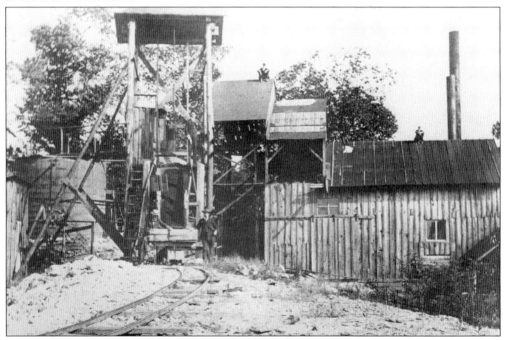

In 1920, the mine had a blacksmith shop for workers who lived at Potomac farms and came by horseback to the mine. As the price of gold rose in the 1930s, the company reorganized again as the Maryland Mining Company and built a new mill. Once again, the company resumed work with tunnels at the 200-foot level. Mint receipts showed $90,000 paid to the company for gold produced from 1936 to 1939. The mine finally closed in 1940. For several years, people continued to look and pan for gold, with few results, and the remaining structures of the mine slowly deteriorated, as pictured below. (Above, courtesy of Chesapeake & Ohio Canal National Historical Park.)

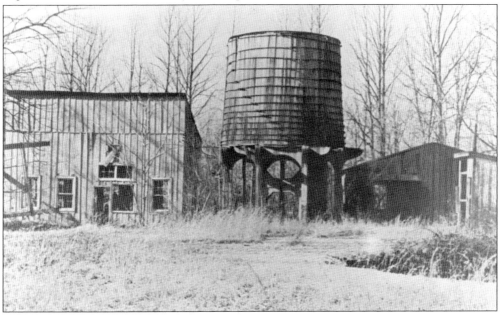

Visitors to the Chesapeake & Ohio Canal National Historical Park can follow the Gold Mine Trail past the trenches where digging occurred. The wooded trail leads to the ruins of the mine building (above) and the cement supports (below) that held the 25,000-gallon wooden water tank used in the amalgamation mill. As the trail is a loop, it can be accessed at several points including behind Great Falls Tavern or at the start of the road leading to the entrance to the national park. (Both, JW.)

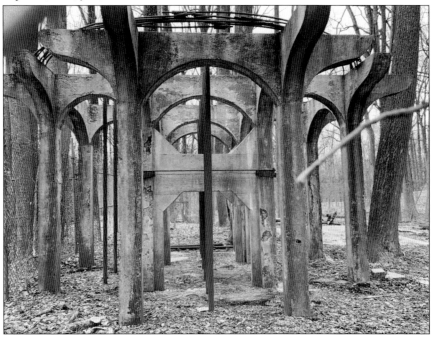

In the early 1900s, two entrepreneurs, John McLean and Steven Elkins, built an amusement park at Great Falls. Included in the park were overlook decks, an observation tower, a dance pavilion, a night light show, a wooden carousel, and a dining hall, pictured on the postcard below. The amusement park closed after floods damaged the structures. In the 1920s, visitors paid 5¢ to cross a swaying wooden bridge to see the falls, above. Entrance fees to the 184.5-mile long Chesapeake & Ohio Canal National Historical Park today allow visitors to walk across bridges and boardwalks to view Great Falls, walk the towpath, or hike the Billy Goat Trail. The bridge and walkway to the falls have concrete supports, and further renovation in 2018 brought additional stability.

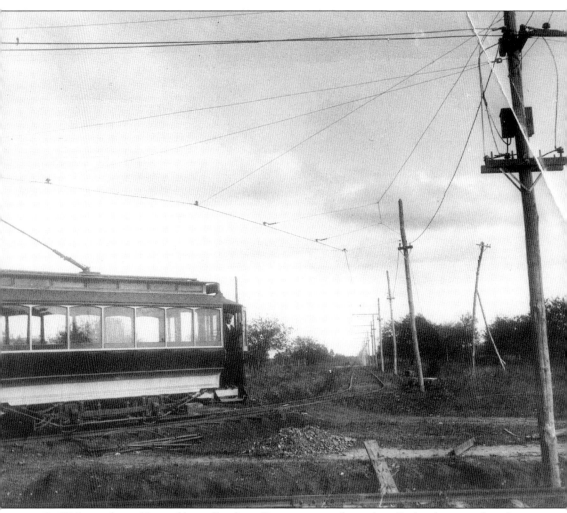

In 1913, people could travel by trolley from Georgetown and switch in Bethesda to another electric streetcar to see the spectacular Great Falls. Trying to attract buyers to a new suburban community, developers constructed tracks for an electric streetcar from Bradley Boulevard and Wisconsin Avenue in Bethesda to River Road. The tracks then went through Potomac countryside to Falls Road and cut across what is now the access road to the Chesapeake & Ohio Canal National Historical Park, then went downhill to a turning loop on the hill overlooking Great Falls Tavern. The Washington & Great Falls Railway & Power Co. suspended operations in 1921 when the developers lost interest. Hikers can still find the turning loop near the Gold Mine Trail. This is a rare photograph of that short-lived streetcar on the countryside tracks.

Three

PASTORAL POTOMAC

For nearly 200 years, from colonial times, Potomac's rolling countryside has drawn people to work the land and build homes with their families. Some farmed corn and wheat, built mills on the streams, and turned the rough fields into lush pastures for livestock. From early times to more recent years, horses were important to families, to help on the farm, to get around, and for the sheer joy of riding through the fields and woods. Potomac's love for horses remains in the storied Potomac Hunt and continued pleasure riding. As roads improved, proximity to urban centers brought new faces to Potomac. Wealthy businessmen and professionals came to enjoy the beauty and tranquility of the countryside and to bring their horses. They sought homes and land where they could entertain friends and family. They started to change the farmland and simpler rustic ways to a more comfortable lifestyle. The early changes and growing population led to the start of modern development by the late 1940s.

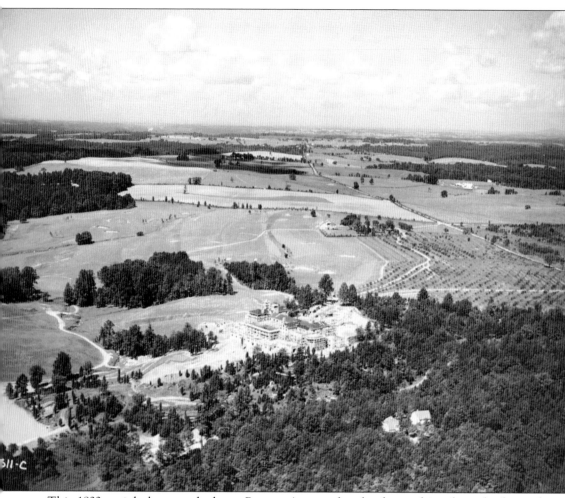

This 1922 aerial photograph shows Potomac's open farmland stretching for miles beyond Congressional Country Club, which was then under construction just off River Road. Sugarloaf Mountain appears on the distant horizon on the right. Most of the land was pasture with some forested areas, but only a few houses can be seen surrounded by vast acreage. In the 1930s, the open fields made it possible to ride horses throughout the area, and Potomac became a center for foxhunts. Change began by the end of the decade as new owners started turning farms into finely landscaped acreage and substantial estate homes began to appear. (Courtesy of National Archives.)

John Saunders (1816–1884) and his wife, Emily, above, built Ellerslie in 1853 using stone quarried nearby. The deed emphasized the importance of the Chesapeake & Ohio Canal by providing a right-of-way for "horse carts and carriages . . . over the tract of land . . . to the river road and also to the canal." A successful farmer, Saunders served two terms as a county commissioner. After he died, his daughter Lucy Saunders operated a boarding school for girls at Ellerslie, while son Richard Saunders continued to farm and raise horses. In the 1890s, Richard's wife, Nellie, became secretary of the Fortnightly Club, which met every two weeks at member homes for recitations of poetry, essays, or songs. Richard Saunders added a frame addition with interior plumbing in 1904. Descendants continue to live at Ellerslie, which is no longer a working farm; the home is pictured below in 1976.

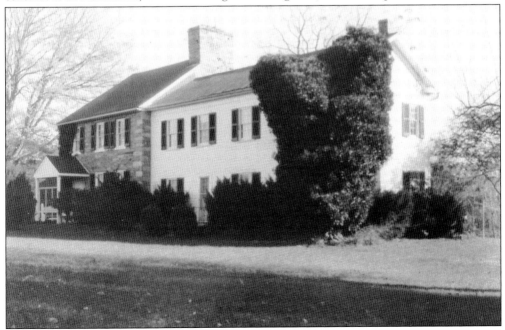

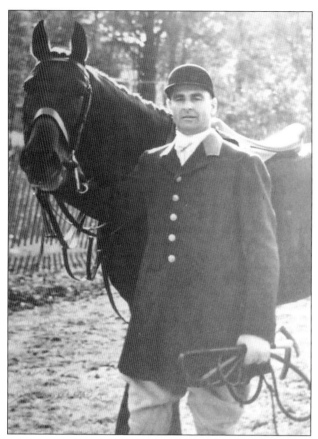

In 1931, the Masters of the Foxhound Association recognized The Potomac Hunt on Charles Carrico's Bradley Farm. Carrico was a horseman, showrider, and foxhunter, and rented out his foxhounds. He had five barns for boarding horses. Three years later, the hounds were moved to Harry H. Semmes's Great Elm Farm on Glen Road in Potomac. Semmes (1919–2014) served as a captain with Gen. George Patton in World War I and became a brigadier general in World War II. In the 1930s, Semmes occasionally invited Patton to join him on the hunt. Semmes, dressed for the hunt in 1947 at left, was master of The Potomac Hunt from 1944 to 1946. In 1945, a property on Glen Road near Travilah Road became The Potomac Hunt clubhouse and kennels for the next 35 years. (Left, courtesy of The Potomac Hunt; below, courtesy of Larry McBryde.)

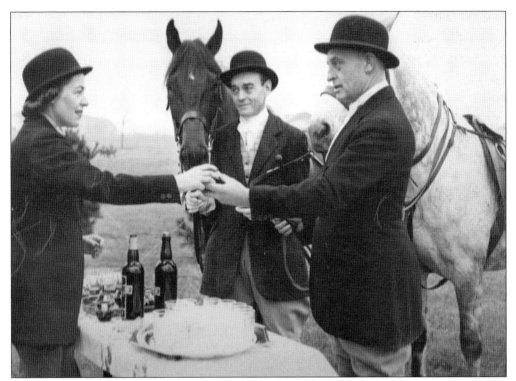

Margaret Cotter gave the hunt award to Charles Paine in 1945 at the Joles Farm. Paine and his wife, Eva, lived on Persimmon Tree Road. Friend Ada DeFranceaux, interviewed in a *Potomac Almanac* article, remembered his dressing in a Santa suit at Christmas and riding his gray horse miles, as far as Travilah Road, to deliver presents. Below, riders and hounds gather for a foxhunt at Ray Norton's farm in Potomac in the 1940s. (Both, courtesy of The Potomac Hunt.)

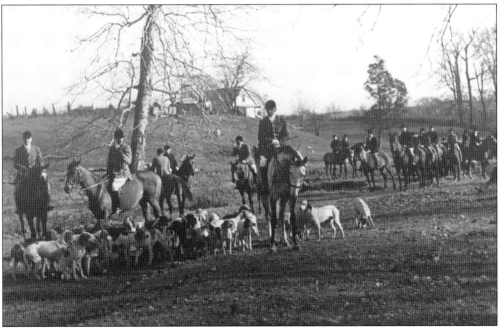

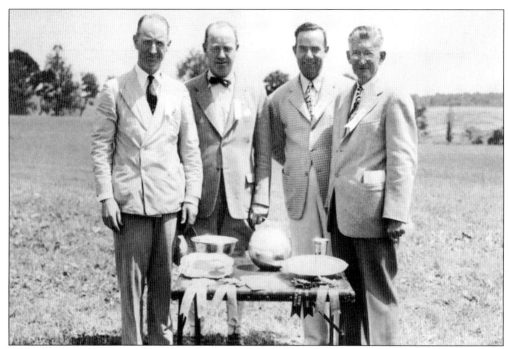

Pictured above, from left to right, Potomac Hunt members Louis "Red" LaMotte, F. Moran "Mike" McConihe, Ray Norton Sr., and Al Earnest held the responsibility as the race committee in the late 1940s. They were business leaders and prominent members of the Potomac community. LaMotte was a colleague and friend of IBM's second president, Thomas Watson, with whom he shared hunt interest. McConihe owned property that became the center for Potomac Village shops and Mitch & Bill's Esso station. Norton owned land that had once belonged to the Clagetts and allowed The Potomac Hunt to use his open fields. Pictured below is a 1968 foxhunt on fields of a Potomac farm surrounded by woods with, from left to right, whipper-in Lyn Carroll, huntsman Halle Burgess, and master of the foxhunt Val Wilson. (Courtesy of The Potomac Hunt.)

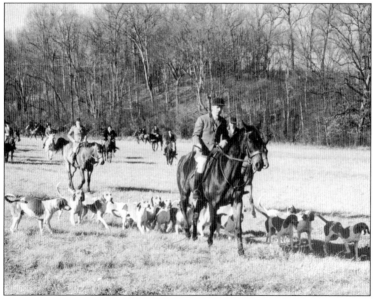

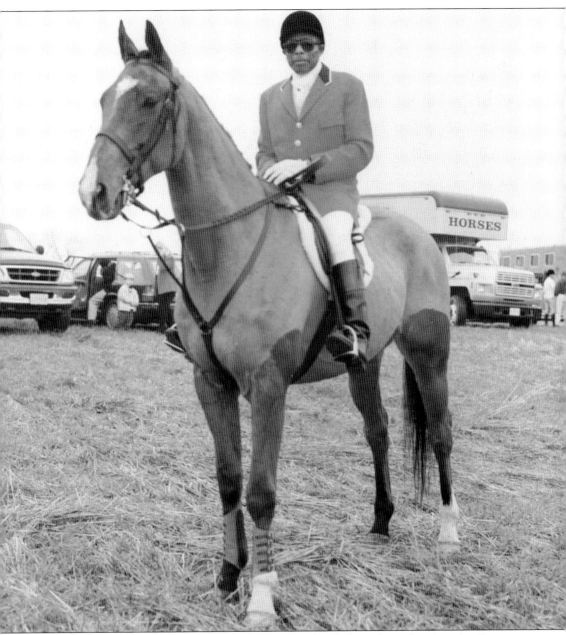

Leonard Proctor, shown astride J-R in 1988, is a revered and almost legendary figure in Potomac. Born in 1930 in Georgetown, Washington, DC, he rode his bike as a teenager to his uncle Johnny Jackson in Potomac who taught him to ride horses. Proctor soon took a job for Red LaMotte at the Captain McDonald House property, where he cared for five horses. In 1947, he started riding with The Potomac Hunt. He began working at the new gas station in Potomac Village, Mitch & Bill's Esso, in 1951. He would care for horses in the early morning before heading to work on cars and never missed a day for 45 years. Proctor taught children to ride horses and then taught them to drive cars. He bartended at Potomac parties and at hunt balls. When he retired in 1995, members of The Potomac Hunt bought him a horse named Blue. He stopped foxhunting in 2015 at the age of 86. (Courtesy of Leonard Proctor.)

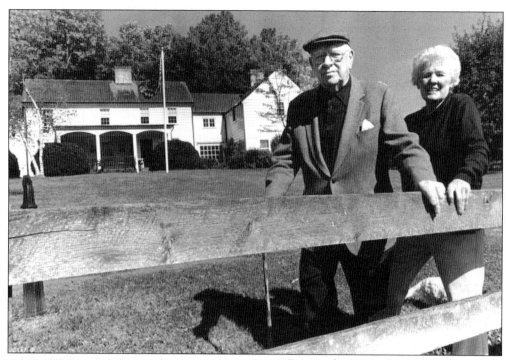

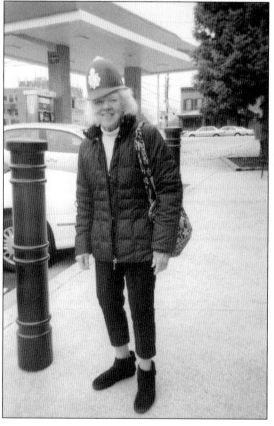

During the 1930s, F. Moran "Mike" McConihe acquired the land that became the home for The Potomac Hunt in 1945 and served as club secretary for 35 years. He fostered the building of shops next to Mitch & Bill's in the 1960s and became president of the first bank in Potomac, Potomac National Bank, in 1968. He was also a founder of St. Francis Episcopal Church in Potomac, which was built on land he donated. He is pictured above with his wife, Margo, at their home in 1988. She was editor of the *Potomac Almanac's* "History of Potomac." Their daughter Elie Pisarra Cain also became a leader in Potomac Village, active in the chamber of commerce, citizens association, and Potomac Day parade. Because of her civic activism she became known as the "unofficial mayor." (Left, courtesy of Sylvia Bogley Biggar.)

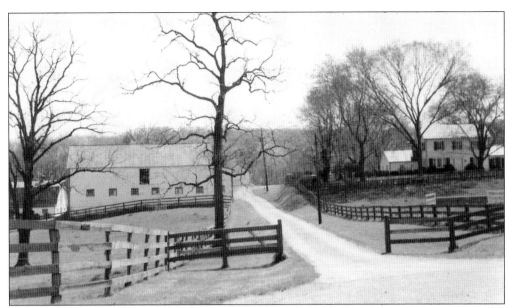

George Plummer and his wife, Frances, were early members of The Potomac Hunt, and in 1932, they bought two farms with 295 acres covering both sides of Piney Meetinghouse Road. Newspaper clippings of the time show a tall striking couple astride their horses. They turned the farmland into lush pastures for breeding cattle. Their efforts resulted in achieving recognition for the top herd in Maryland with 60 cows and 2 bulls. The peaceful and quiet nature of Potomac during the early 1970s is evident in the winter photograph at their farm above. (Both, courtesy of Larry McBryde.)

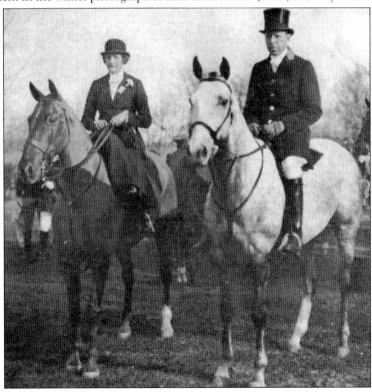

The rolling pastures on the Plummer farm looked much like they always had when Potomac resident Larry McBryde took these photographs in 1974. A red barn stood out on the green pastures where the Plummers had planted acres of bluegrass. Their property, curtained by woods, provided an iconic countryside scene of old Potomac as far as one could see. They had no children, and left their farm and acreage to charities. (Both, courtesy of Larry McBryde.)

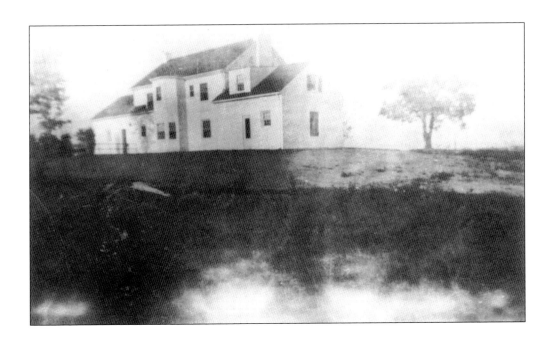

Samuel and Anita Bogley lived at Hobby Hill, the home Bogley built in Potomac in 1939. The rear of the home is shown above in 1941, the same year that the couple was photographed with their firstborn daughter, Sylvia, at the front portico, below. Samuel's father, Emory H. Bogley, had been a lawyer and tax collector. Sam Bogley established a real estate company in 1936 and a mortgage banking firm in Chevy Chase in 1950, which expanded to several states. A leader in the development of Potomac Village, he was a founder of the Potomac National Bank in 1957 and began construction of Potomac's large shopping area at the crossroads, called Potomac Place, in 1966. Bogley was an avid horseman and a master of The Potomac Hunt, where the popular couple had many social and business friends. (Both, courtesy of Happy Bogley Galt.)

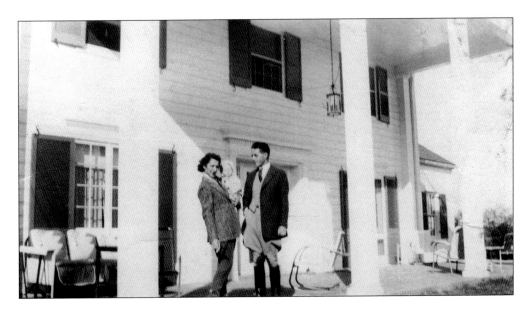

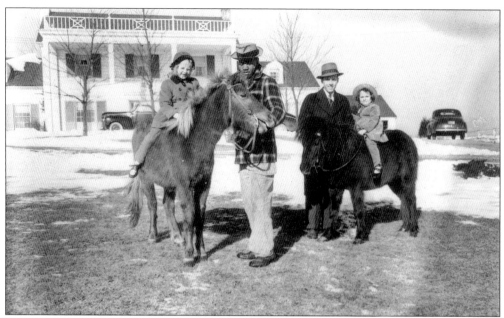

From left to right, Sylvia and Patricia Bogley are shown on their ponies with Charles Holston and their father, Sam Bogley, at Hobby Hill around 1946. The girls, like many Potomac youngsters, learned to ride early and grew up to join The Potomac Hunt. The Bogleys had three daughters, Sylvia, Patricia, and Happy. After Anita Bogley died, Sam Bogley remarried, and he and Rose Marie had a daughter, Hilleary. Taken roughly in the same time period as the photograph above, Thomas Neil Darling's photograph below shows Bogley at a hunt race. Bogley died after a foxhunting accident in 1967 at the age of 51. (Both, courtesy of Happy Bogley Galt.)

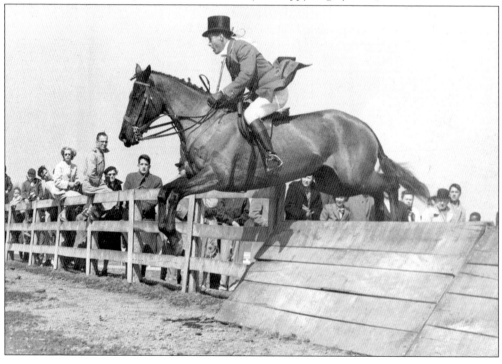

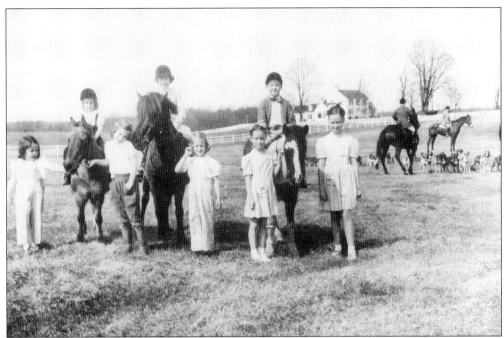

Bogley daughters and the children of other members riding in The Potomac Hunt are pictured above at Ray Norton's Western Breeze Farm in 1947 as the hunt was about to begin. The youngsters were, from left to right, Patricia Bogley, Molly Poole, Virginia Poole, Gay Hawkins, Sylvia Bogley, Elizabeth Murphy, Michael McConihe, and Marie Dennett Murphy. Ray Norton's farm included 166 acres that had originally been part of the Clagett family farm. Leonard Proctor is shown below with the children he taught how to ride and jump in 1946 as they learned to prepare for hunt races. He wrote their names on the photograph and had copies made for each of them. (Above, courtesy of Happy Bogley Galt; below, courtesy of Leonard Proctor.)

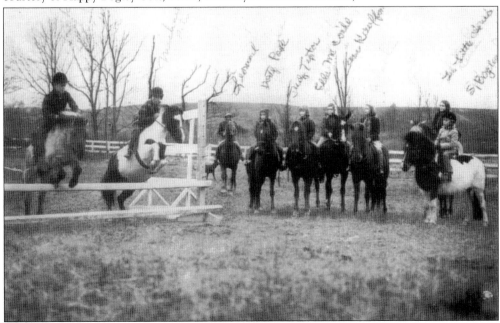

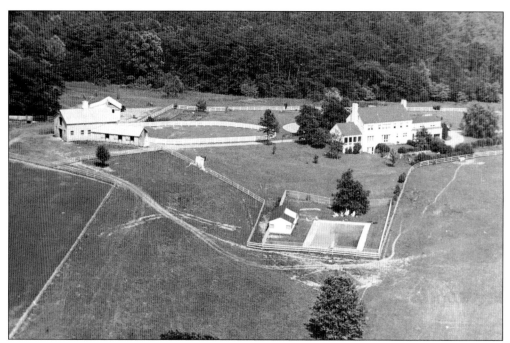

Around 1950, the Bogleys moved to a larger home, which they also named Hobby Hill Farm, with larger acreage and a barn for their horses on Glen Road. Nearby, Three Sisters Road in Potomac is named after their daughters Sylvia, Patricia, and Happy and is part of the original working farm. The aerial photograph above shows the house and property, including the horse training area. The nearly 500-acre farm also had cattle and acres of wheat and corn. The piles of snow on the driveway at Hobby Hill Farm in 1958 below resulted from the massive snowfall from the nor'easter that year. (Both, courtesy of Happy Bogley Galt.)

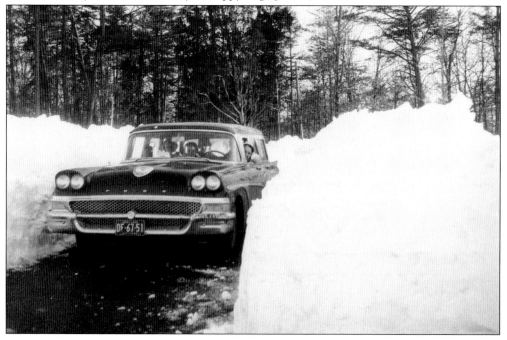

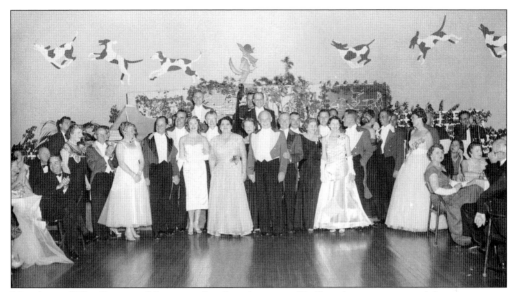

Members of The Potomac Hunt socialized at the annual ball and at parties to celebrate winners. Among those at The Potomac Hunt Ball in 1956 pictured above were Charles Paine standing at front center; Bill Carroll, to the right of Paine; and Sam Bogley, sixth person to the right of Caine, with Lyn Carroll next to him. Each of the men was a master of the foxhunt in various years. Bogley is shown below as Ada DeFranceaux fixes his stock and other members look on. The DeFranceaux family were close friends of the Bogleys and among the prominent people of Potomac for many years. (Both, courtesy of Happy Bogley Galt.)

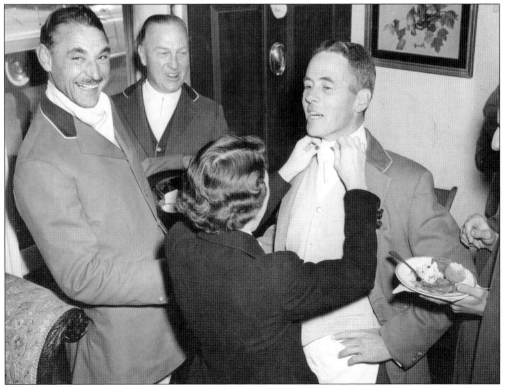

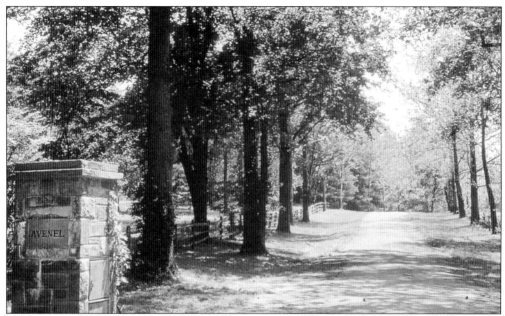

In the 1940s, William Rapley, a wealthy Washington publisher, bought several parcels of adjoining land to form Avenel farm. He and farmer Buddy Eyler cleared the fields and built barns and stables. Avenel had one of the largest registered herd of shorthorn cattle on the East Coast. Rapley also had champion bulls, pigs, chickens, and sheep. Barley, wheat, corn, and alfalfa were planted on the fields. Dozens of Washingtonians brought their horses to board at Avenel. The entrance road and marker are shown above in 1974. The 950-acre farm was sold in 1980 to become the Avenel development of estate homes and a championship golf course. A stable from Rapley's Avenel Farm remains today as an equestrian center in the Avenel community. (Above, courtesy of Larry McBryde; below, JW.)

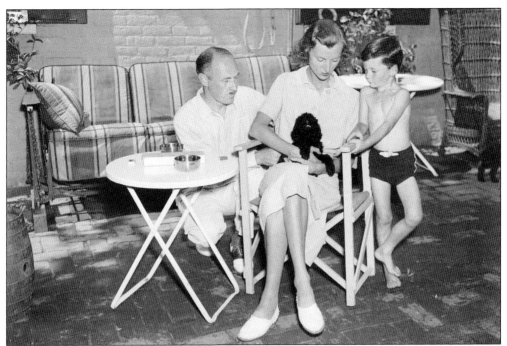

In the 1930s, Drew Pearson wrote a political column for the *Washington Times-Herald* called "Washington Merry-Go-Round." He bought 200 acres with Potomac River views in 1939 for his second wife, Luvie, who had a son, Tyler Abell, from a previous marriage. The Pearson family, pictured above in 1937, lived in Georgetown and used Merry-Go-Round Farm as a weekend getaway where they hosted political figures and movie stars. Pearson started a dairy at the farm and sold a byproduct as "Drew Pearson's Best Manure—All Cow, No Bull!" After Pearson's death, his stepson, Tyler, who became protocol chief for Pres. Lyndon Johnson, took over the farm. In 1990, the Abells developed a luxury residential community, preserving 140 acres for scenic views and forest trails. The restored barn is an equestrian center. (Above, courtesy of Library of Congress; below, courtesy of King Barn Dairy Mooseum.)

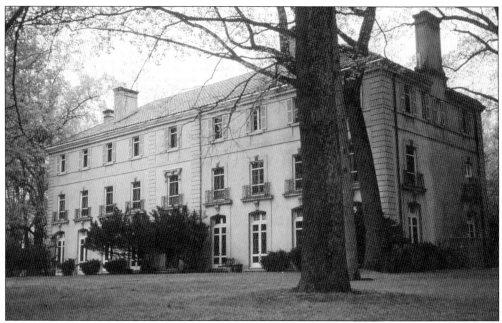

Marwood mansion and gatehouse sit above the Potomac River on 192 acres. Wealthy socialite Samuel K. Martin III and his wife, Jane C. Martin, a Ziegfeld Follies dancer, bought the farm from a Magruder in 1930 and built a lavish estate house. In 1934, they leased the estate for a summer and weekend retreat to Joseph P. Kennedy, whose children, including John, Robert, and Ted, often stayed at the house. Guests included Franklin Delano Roosevelt, for whom Kennedy installed a special elevator. In 1935, Martin died of a heart attack at age 26. His wife lived in the house until 1943, when the property was sold to Col. H. Grady Gore. Estate homes were built on the acreage in the 1990s, and Ted Leonsis, owner of the Washington Capitals and other major sports teams, bought historic Marwood in 2011. (Both, courtesy of M-NCPPC.)

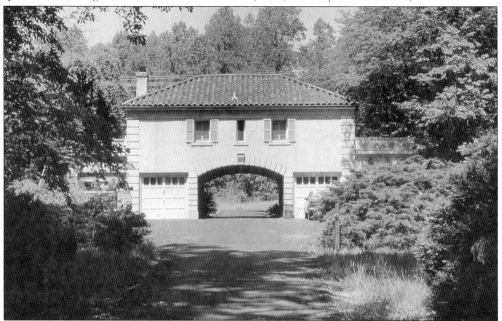

Four

POTOMAC VILLAGE

In the 20th century, Potomac Village began to grow into a shopping and business hub as the broader Montgomery County flourished. The county's population rose from 30,541 in 1900 to 49,206 by 1930. Transportation and farming technologies were also developing. Potomac farmers started using more modern techniques for planting and harvesting. A trolley came from Georgetown to nearby Cabin John in the 1890s and then from Bethesda to Great Falls in 1913. Potomac Village had a blacksmith until the 1920s, when gas pumps appeared along with farm trucks. The popularity of Great Falls and the transportation to and through Potomac brought more visitors from Washington, DC, and more travelers passing through. Yet, Potomac remained a quiet rural area with its country ways, adapting slowly to electricity and telephones. Families generally relied on the farms for milk, eggs, and produce but came to Potomac Village for staples and extras, such as coffee, sugar, kerosene, dress materials, and penny candy. Farming continued quietly through the Roaring Twenties and the Great Depression. It was not until the late 1930s that real change began to be felt and seen.

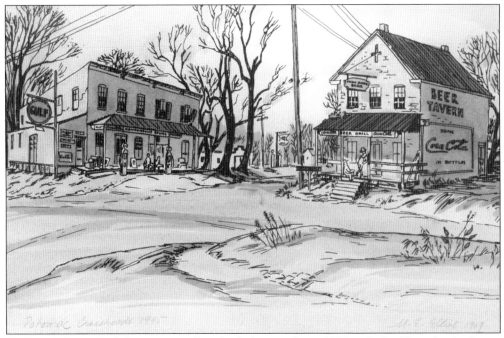

After Prohibition ended, Potomac Village had a beer parlor in 1936 in the building that had once been Offutts X Roads Market. In 1929, the Hitchcocks bought the Offutt store and sold some grocery staples and hardware supplies. They later tore out a counter for booths and added outside tables for a summer beer garden. The beer parlor days ended when the building was torn down in 1948 for construction of Mitch & Bill's Esso gas station. Potomac resident Margaret Elliot created a drawing in 1969, above, of Potomac Village as it was in 1945 with the beer parlor and gas pumps in front of Perry Store. Inside Mitch & Bill's gas station, a mural on one of the walls also shows Potomac Village with the beer parlor and with Dunhams' Automotive. (Above, courtesy of Larry McBryde; below, courtesy of Ralph Buglass.)

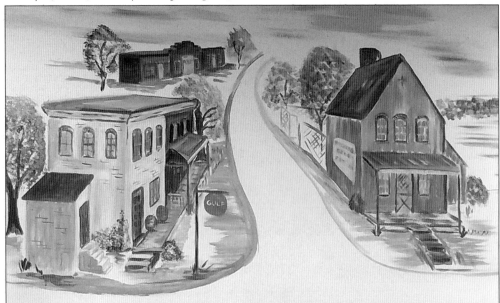

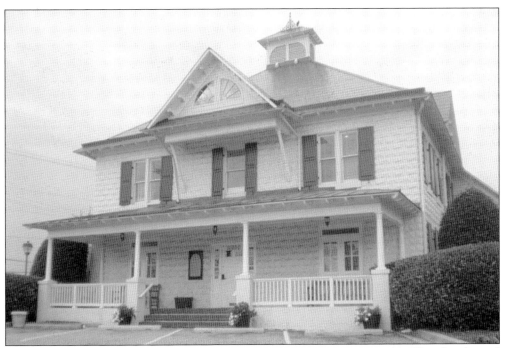

Edgar Perry built his home, which became known as the Perry House, in 1902 of handmade sand cement blocks called formstone. The size and prominent location of the house, which stood above the crossroad, gave evidence of the success of its owner. Pictured above in 2016, each block was formed out of a single mold and laid in place when a sufficient number were completed. Later owners converted the house to stores, the Happy Pickle restaurant (seen below in 1974), and a bank. Today, the building has a realtor and mortgage offices and stands as a reminder of Potomac's earlier days. (Above, courtesy of Ralph Buglass; below, courtesy of Larry McBryde.)

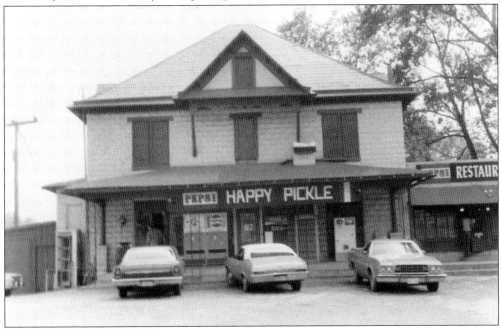

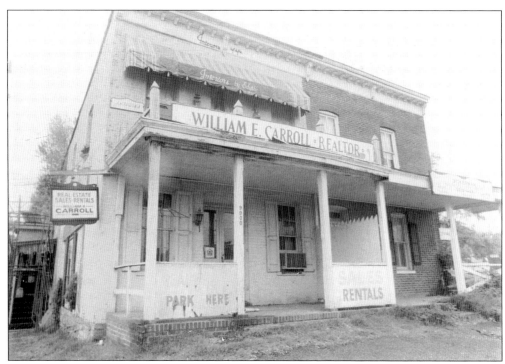

Perry Store has gone through changes over the years to reflect the changing times and different owners. The building's solid structure allowed much versatility in how it was used. It had been a general market during and after the Perrys, and it became the Henderson's Store in the early 1940s. In the 1950s, real estate developer Sam Bogley owned and occupied the building for a branch of his business. His wife, Anita Bogley, and her friend Lyn Carroll opened The Surrey in the rear of the building. After Sam Bogley died in 1967 after a freak riding accident, William E. Carroll Realtor moved into the downstairs, and Interiors by Edythe used the upstairs of the building. In 1986, the building had to be moved 21 feet to allow for the widening of Falls Road. (Below, courtesy of Larry McBryde.)

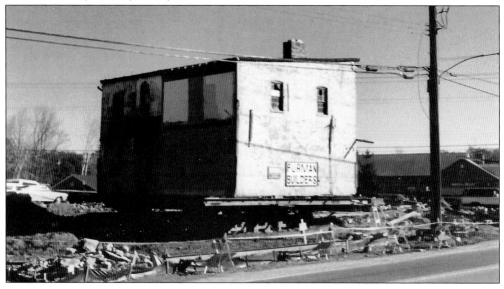

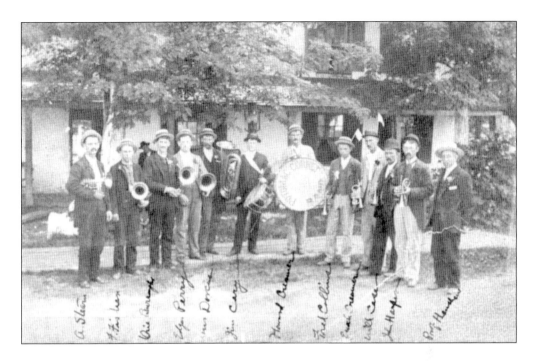

Brass bands were popular in America during and after the Civil War. The Potomac Cornet Band began in the 1880s. Edgar Perry (fourth from left above) holds his horn proudly with other prominent Potomac residents who were members of the band in 1891. Anson Ball, son of Cora Perry Ball and grandson of Edgar Perry, was one of the founders of the Potomac Band in 1925. He is fifth from right in the 1933 photograph of the band below. With more instruments, including a drum and clarinets, the band was not a continuation of the cornet band. The group played for fundraising at charitable and community functions, including The Potomac Hunt, until 1968.

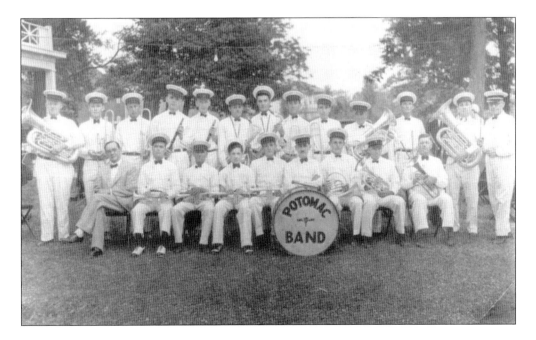

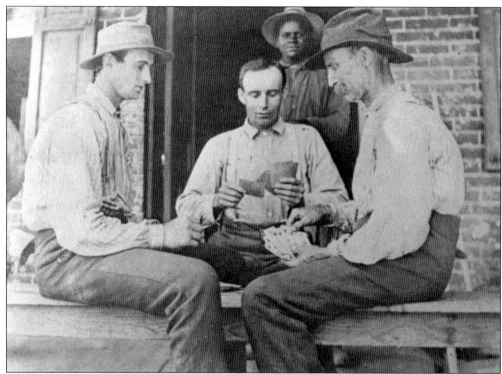

Perry Store was a center for social life where workmen could play cards around a potbellied stove in the winter or on the front porch in the summer. The c. 1920 photograph above, attributed to Anson Ball, appeared in the 1970 booklet "History of Potomac," showing George Jackson in the doorway and, from left to right, Clay Fisher, John T. Ball, and Watt Fields playing cards on the porch. Square dancing also took place upstairs in the store with a string band. Later, square dances were held at the hall near Great Falls. With the newly constructed Congressional Country Club, golf became a passion for visitors from Washington, DC, as well as for some of the businessmen in Potomac, in 1923. (Below, courtesy of Library of Congress.)

Anson Ball lived in a frame house that remains in Potomac Village, as shown above in 1976, near his grandfather Edgar Perry's formstone house. Brothers Charles and Samuel Case also built formstone houses similar to the Edgar Perry House in 1914 at the corner of today's Persimmon Tree and River Roads. Their mother, Elizabeth Case, had originally owned the property along with a 172-acre farm on Falls Road in 1884. Charles and his wife, Emma, lived in the house, and after he died, Emma continued to live there until 1954. The house has changed little on the outside. (Above, courtesy of Larry McBryde; below, courtesy of M-NCPPC.)

In 1925, Potomac School was a two-story building with its only two classrooms on the second floor, including fourth and fifth grades together in one room. The fourth-grade class pictured above in 1925 included future county executive Neal Potter at far right in the middle row. A new building for the Potomac School opened in 1928 with three rooms for 65 children. A wing was added, as shown below, in 1947 for an auditorium, cafeteria, and classrooms for seven teachers and 173 children. With 497 students in 1970, the school had yet another addition. In 2018, the school building was torn down for construction of a larger, more modern elementary school. (Above, courtesy of Larry McBryde.)

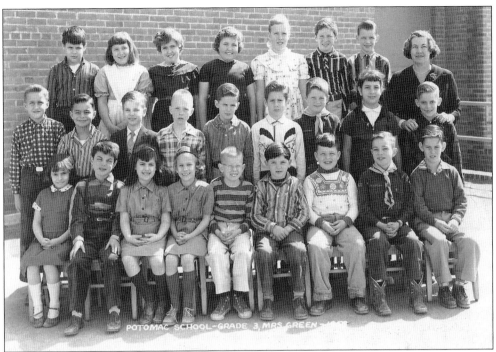

These class photographs show children at the Potomac School in the third grade in 1958 and fourth grade in 1959. The style of the 1950s common in Potomac and other locales saw girls wearing dresses or skirts and most boys wearing shirts with buttons. Young Larry McBryde is second from the right in the top row above and first on the right of the top row below. He recalled Cold War safety drills and, as a young child, taking a long ride on a school bus to pick up children from farms in Travilah. The high quality of Potomac public schools has been a factor in attracting families to the area. Many highly regarded private schools have also located to the area since the 1960s. (Both, courtesy of Larry McBryde.)

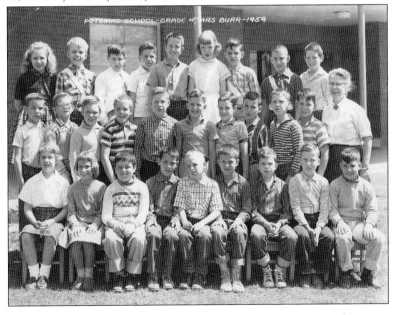

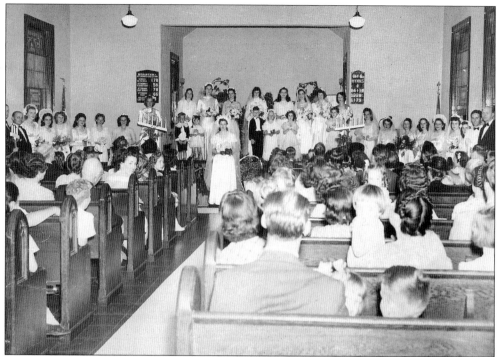

Population growth also led to expansion of the historic Potomac Methodist Church. In 1948, the congregation enjoyed a display of period wedding dresses at the Sweet Remembrance Fashion Show of the ladies' bible class. The child dressed as a "Tom Thumb" bride at center was young Sylvia Bogley. Featuring weddings in this manner helped convey a message on the sanctity of marriage. The building was totally rebuilt and expanded with a new facade in 1969. It is pictured below in 2019 with the cemetery and graves of many of the early residents of Offutts Crossroads and Potomac Village. (Below, courtesy of Tim Shank.)

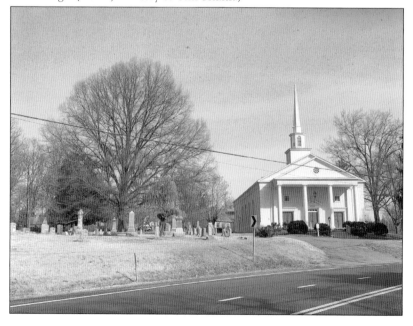

Mitch & Bill's Esso opened in 1949 in the space where the Beer Parlor had been and, before that, Offutts X Roads Market. Clyde Eastham "Mitch" Mitchell (left) and William Schumacher founded Mitch & Bill's. In addition to quality service and auto repair, Mitch & Bill's became another place where people stopped by to chat and sit a while. The friendly owners were always ready for a drop-by conversation. In snow and rain, they opened the door for children to wait for school rides. Mitch & Bill stayed together as partners and friends for decades. (Right, courtesy of Mike Mitchell.)

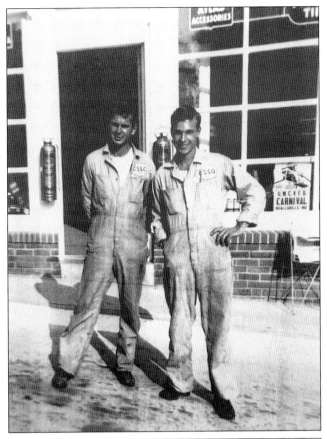

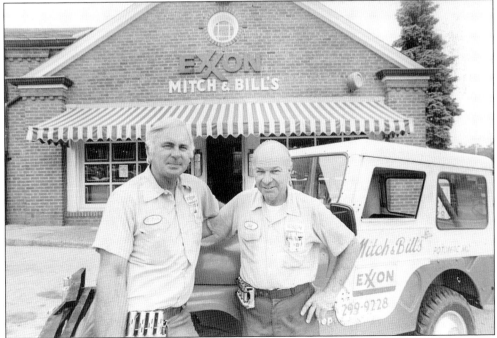

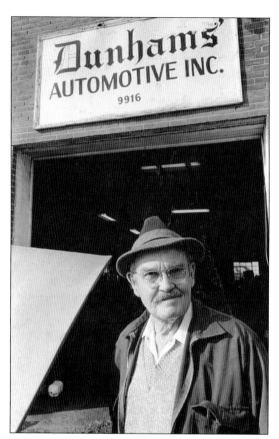

Anson Ball ran a garage that he leased to Al Dunham in 1942, and it soon became known as Dunham's Motor Service and later Dunhams' Automotive Inc. Dunham was another person who, in addition to sterling mechanical repair skills, always had a smile and a moment to greet a neighbor and chat. Dunham said in an interview for *Potomac Almanac* that he and Mitch Mitchell and their two businesses shared knowledge, parts, and tools. Dunhams' garage was an institution in Potomac for 50 years. (Below, courtesy of Larry McBryde.)

The Potomac Hunt and riding horses brought new business to Potomac Village. The Surrey expanded by 1959, moving from the rear of what had been Perry Store to the newly built Potomac Village market place behind Mitch & Bill's. Lyn Carroll had seen a surrey on a vacation trip and decided to find one to place outside the store's new location. "The tack store, The Surrey, had that wonderful smell of leather and potpourri when you entered and upstairs was a musty attic called 'Horse Heaven' where you could purchase used items such as riding boots, bridles, or riding coats," remembered Margaret Herman McBryde. Carroll is pictured below outside The Surrey in 1988. After 56 years in Potomac, The Surrey moved to Darnestown in 2009 to be closer to the horse community. (Right, courtesy of Happy Bogley Galt.)

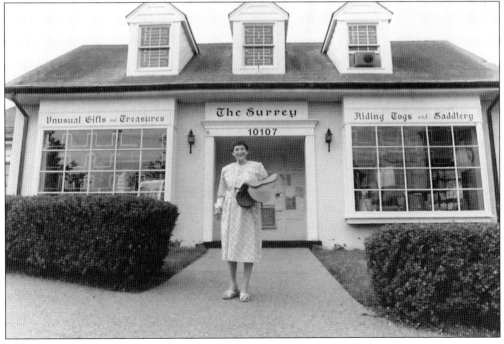

Unusual Gifts and Treasures The Surrey Riding Togs and Saddlery
10107

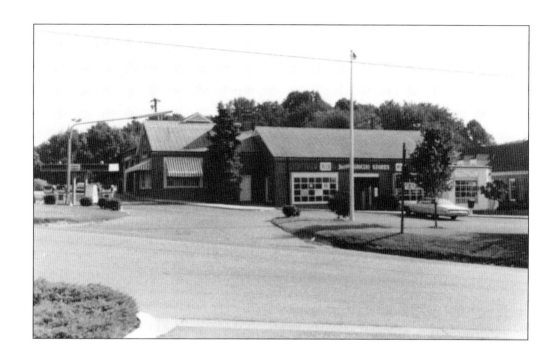

The District Grocery Store (DGS) opened behind Mitch & Bill's gas station in the early 1950s. It filled the void left by the Perry Store and Offutts X Roads Market, although Potomac residents were also driving to larger food stores in Bethesda. Ben Counselman owned DGS, also labeled Potomac Supermarket. By 1959, DGS stood next to Country Squire Cleaners, the new Potomac National Bank, a hardware store, and a pharmacy in the small shopping area named Potomac Village. "Potomac Village even had a hitching post out front where you could tie your horse up, go into the pharmacy to read the comic books, drink a soda or catch up on the local gossip," Margaret Herman McBryde recalled. Across River Road, a larger shopping center named Potomac Place, developed by Sam Bogley, opened in 1967 with the first supermarket and a large Drug Fair, below. (Both, courtesy of Larry McBryde.)

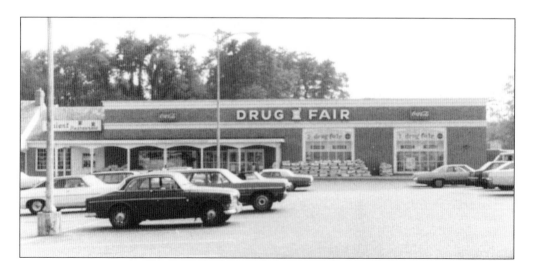

Potomac Almanac began in 1957 as mimeographed sheets and in booklet form for 25¢ a copy soon after. A group of Potomac women sat around a table in the backroom of The Surrey in the Bogley Real Estate building sharing and writing local news and cutting and pasting it together. Many Potomac Hunt women helped, including Anita Bogley, Lyn Carroll, Eva Paine, Midge Galliher, and Ella Haug. Local artist Migs Eliot contributed drawings. Cissy Finley Grant covered many important events as a reporter and photographer. The Tally Ho restaurant opened in 1968 and became a popular gathering spot. Drawings of horses appeared on its signage and that of the Country Squire Cleaners. Both establishments continue in a new location on the other side of Mitch & Bill's. (Above, courtesy of Tim Shank; below, JW.)

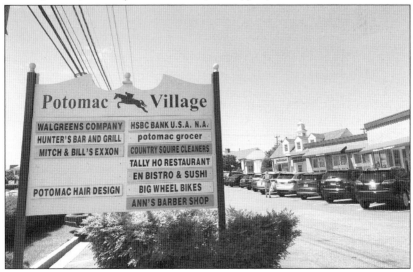

Anne Christmas was the first editor of the *Potomac Almanac* and later became a reporter for the style section of the *Washington Post*. Later editors included Margo McConihe and Lutie Semmes. Beppie Noyes, wife of the *Washington Star* editor Newbold Noyes, provided drawings of foxes in hunt dress. She later authored children's books including one about the Kennedy Center cat. Pictured above are, from left to right, Lorraine Tipton, Sam Bogley, and Anne Christmas; below are unidentified, Sue Lewis, Margo McConihe, and Eva Paine around 1960. (Both, courtesy of Happy Bogley Galt.)

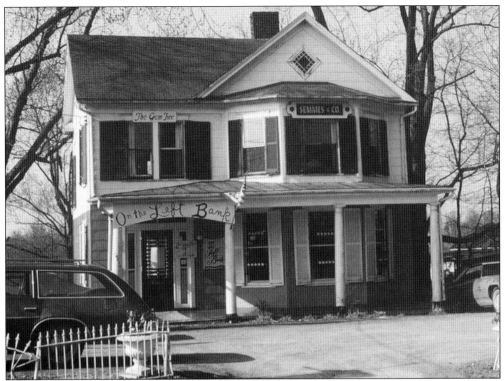

On the Left Bank, above, was a store for clothing and gifts in a shingled frame house next to the Perry House in the 1960s. Semmes & Co., owned by Harry Semmes Jr., had the top floor of the house for his real estate business. Semmes was a master of the foxhounds with The Potomac Hunt from 1973 to 1979, like his father had been from 1944 to 1946. The buildings were located prominently at the crossroad intersection, making it easy for people to go to the Happy Pickle to eat, drink, and socialize or to browse at On the Left Bank. (Both, courtesy of Larry McBryde.)

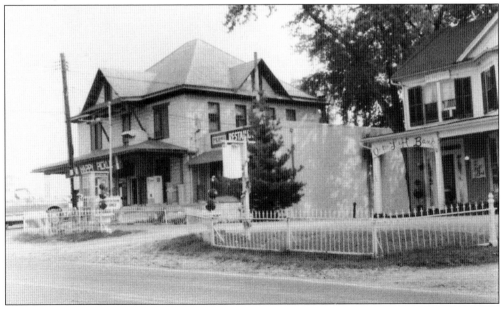

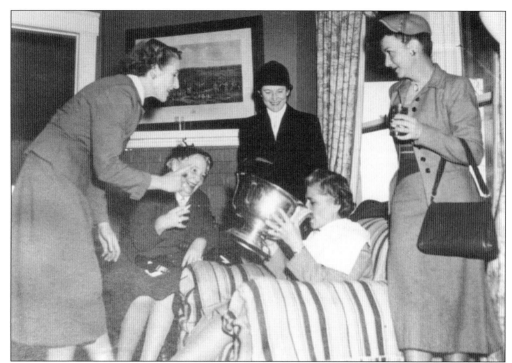

Stombocks Saddlery was housed in Edgar Perry's first home on Falls Road, which had also been the Methodist church's parsonage in 1910. Stombocks marketed that it had "Everything for your horse" including veterinary supplies. Above, at a Potomac Hunt party in 1955, Anita Bogley (left) and Lyn Carroll (rear) celebrate with Ruth Atwood, who humorously drinks out of The Potomac Hunt Cup that her husband had won. (Above, courtesy of Happy Bogley Galt; below, courtesy of Larry McBryde.)

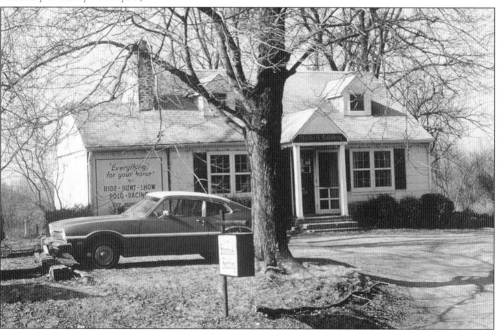

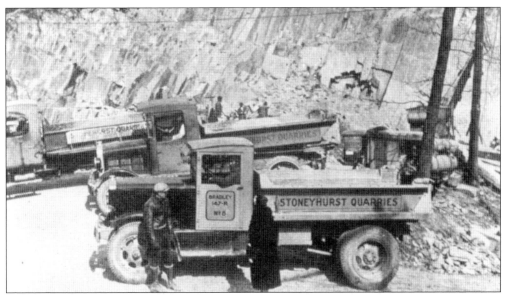

Lilly Moore Stone, at the age of 63, started a quarry in 1924 on land once owned by Magruders and Offutts. Stone (in a black dress by the truck above) named the Magruder house and quarry she owned Stoneyhurst and personally managed operations. The stone was used in the National Cathedral, National Zoo, and thousands of homes and buildings. Her son J. Dunbar Stone worked with his mother and inherited the quarry upon her death in 1961. His son John P. Stone later took over the management until he sold the business in the 1980s. The quarry continued operating until 2006. A condominium has been built on the quarry site, with terraced walls of the colorful stone. The family photograph below shows, from left to right, John P. Stone and parents, Katherine and J. Dunbar Stone. (Below, courtesy of Lilly Stone Lievsay.)

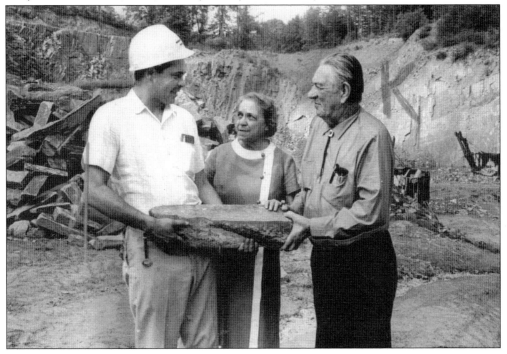

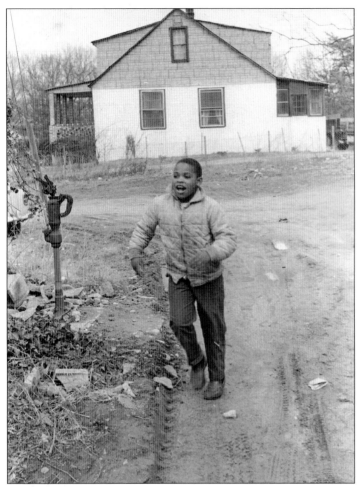

Near the location of the former Bells Mills, William Dove, a former slave, bought 36 acres for $210 in 1880. Originally known as Snakes Den, the community adopted the name Scotland in the 1920s. By the 1950s, the community had 50 families, most descended from those who had lived there after the Civil War. Frances Palmer lived in a two-story home with a front porch and relied on water from the outdoor pump that served the entire community. Her neighbor's son Alan Twyman is seen running past her house. Her home, shown below near the construction for new town houses and running water for the community, remains as a residence in the neighborhood. (Both photographs by Alan Siegel.)

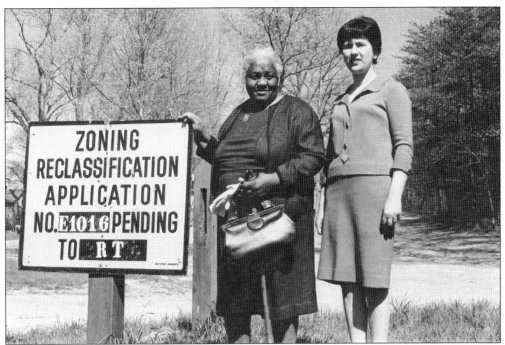

Scotland residents managed without running water or electricity until some of the residents and some white neighbors advocated for change and formed the Scotland Community Development Corporation in the 1960s to rebuild the community. They developed plans for affordable housing that residents could buy with their land and receive equity in their homes. Trailer homes were placed on the property to temporarily house some of the residents while town homes were built. Community member Geneva Mason, on the left in the c. 1967–1968 photograph above, and Joyce Siegel were leaders in the redevelopment effort. Today, Scotland has modern town houses and a recreational center. Across the street, the original Scotland African Methodist Episcopal Zion Church, built in 1915, still holds services.

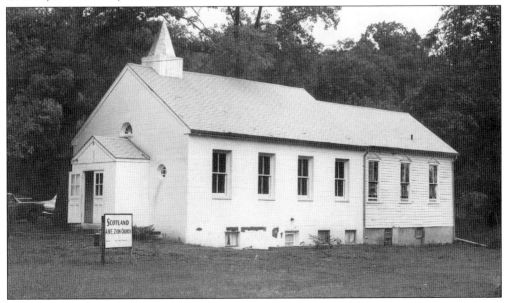

Tobytown is a small historic community in Potomac started by freed slaves who bought land near the road to Pennyfield Lock after the Civil War. One of the founders, William Davis, had been working on a farm near Seneca when he purchased four acres of land for $8 in 1875. Other founders were Aislie Martin and Emory Genus. Residents worked on surrounding farms as laborers, domestics, cooks, and gardeners. When the Potomac area changed from working farms and no longer required as much labor, the community slipped into poverty. An urban renewal program replaced the old rustic houses, as seen above, in the late 1970s with town houses and a community center. (Below, JW.)

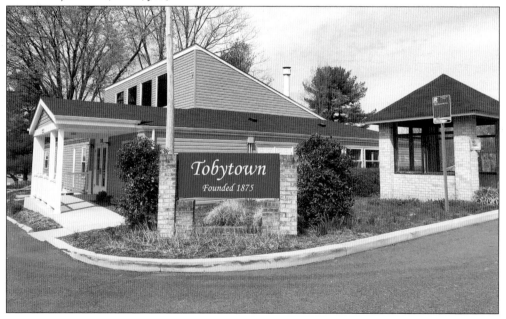

Five

RURAL TO SUBURBAN

People started coming from Bethesda, Chevy Chase, and Washington, DC, for the country feeling and space of Potomac after World War II and into the 1950s. Some wanted summer homes, some wanted more acres to raise and board horses, and others wanted larger homes. Nearly everyone came to get away from crowded city streets. Farms began to change as owners aged and their families left Potomac. Land became available to meet a new and more pressing need for housing. In 1949, the first plans for development houses emerged with modest acreage, but by the 1970s, larger developments with smaller plots of land were multiplying at a rapid pace. Newcomers found new shopping centers, new churches, and both public and private schools. They could live near and enjoy the beauty of the river and canal at Great Falls and eat at quaint taverns and inns along the roads. Potomac lost many of its open fields but gained a new generation of families for its future.

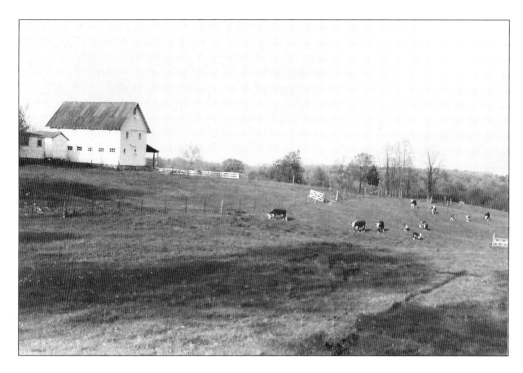

In the 1950s, some dairy farms still operated in the vicinity of Potomac, such as the James Flaherty Farm, pictured above, on Falls Road not far from Potomac Village. Neighbors and their children could stop by to buy some milk. Below, McBryde children Larry and Sarah are shown visiting the farm to see the new calf in 1954. (Both photographs by F. Webster McBryde.)

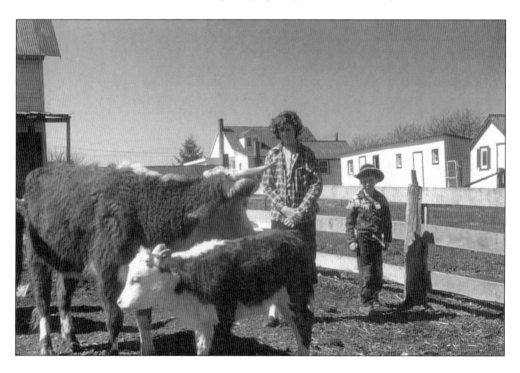

F. Webster McBryde and his wife, Frances, pictured at right, moved with their young children Larry, Rick, and Sarah to the country that was Potomac in 1953. McBryde was a professor of geography and a cartographer who taught at the University of Maryland. The McBrydes lived in a house on Falls Road in Potomac Village, pictured below, just a few doors away from the Perry Store. Their house had been ordered from a Sears catalogue and built by earlier owners around 1926. The McBrydes added a stable on their four-acre property in 1956 when daughter Sarah wanted a horse, which Frances McBryde named Bingo. (Both, courtesy of Larry McBryde.)

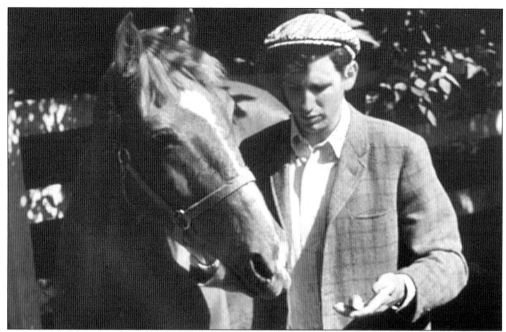

Larry McBryde owned Bingo after his sister left, as shown above. His memories of growing up in Potomac recall open fields and "a community feeling where everyone knew everyone else." He remembers the baseball diamond on one corner of the crossroads in Potomac Village where he played with friends and where a traveling circus with elephants came each year. He also remembers the Paddock restaurant next to Dunhams' Automotive. In the 1970s, as farms were being sold, McBryde took photographs to preserve memories of how Potomac once looked. "When I took many of these photographs back in the 1970s, progress was always looking over my shoulder," he commented. Below is a view of Potomac crossroads in 1974 with only a few shops and open farmland in sight. (Both, courtesy of Larry McBryde.)

Harold Herman, an electrical engineer, moved his family from Silver Spring to Potomac in 1961 for a taste of country. Their house on Persimmon Tree Road backed up to Avenel Farm. "By Christmas, my two brothers and I each had our own horse," recalled daughter Margaret Herman. The youngsters participated in Potomac's Pony Club and foxhunting. "Potomac was a friendly, open community that allowed a lot of freedom to roam," she added. Harold Herman went on to become a successful thoroughbred racehorse breeder, and each of his children found a niche in the horse world. Margaret's brother Joseph took the picture at right of her on her pony Archie in the late 1960s. She took the photograph below at the Potomac Hunt Races in 1999. (Both, courtesy of Margaret Herman McBryde.)

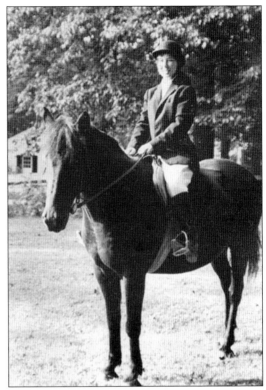

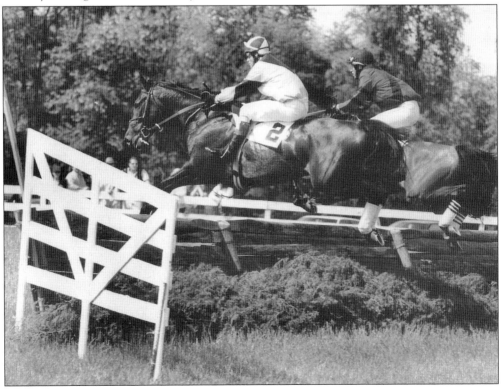

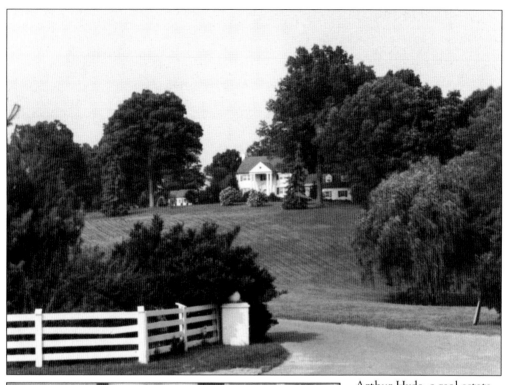

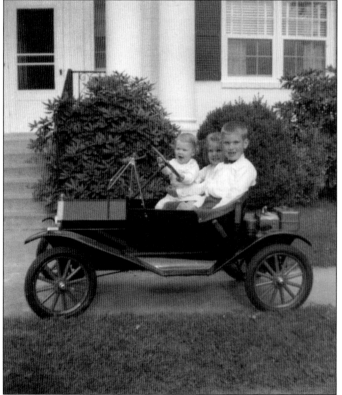

Arthur Hyde, a real estate investor who developed the Congressional Plaza shopping center in Rockville, Maryland, in the 1950s, bought a home on 16 acres in Potomac in 1952 with his wife, Mary Ann, for their young family. He also developed Hyde Field Airport in Clinton, Maryland, among other properties. The family's house, above, and property were sold to Norwood School, an independent day school, in 1995. Pictured at left in their miniature car in 1962 are the Hydes' son Art Hyde Jr. and daughters Ann and Carolyne Hyde. (Both, courtesy of Art Hyde Jr.)

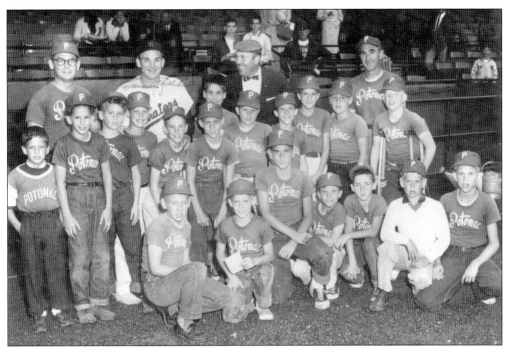

Some who moved to Potomac in the 1960s bought property on country roads, and others bought lots in emerging neighborhoods. Families in new neighborhoods of Potomac started youth sport teams. Boys on the Potomac baseball team had the special treat of going to a Washington Senators game and meeting top hitter Harmon Killebrew, who also signed their team photograph, above, in 1955. The original Senators American League team was founded in Washington in 1901 and became the Minnesota Twins in 1960. Children of families who moved to Potomac from more urban areas in the 1950s also enjoyed the experiences of nearby farms. Below, the Hyde children and a friend climb on a corn-picking assembly. (Below, courtesy of Art Hyde Jr.)

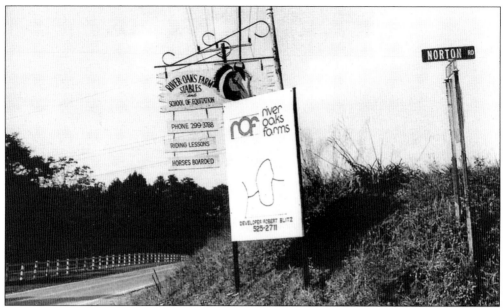

The farmland owned by Montgomery Clagett, son of early settler Oratio Clagett of Offutts Crossroads, changed after fire destroyed the original barn, smoke house, and home. Clagett built a new house in 1878 that had water from a spigot and one of the first bathrooms in that part of the county. The property eventually passed from the Clagett family. Purchased by Ray Norton in 1935, who named the farm Western Breeze, it became known locally as the Norton farm and later River Oaks Farm on Norton Road. In the 1970s, new Potomac communities developed with vintage names such as River Oaks and Clagett Farm. The change to the Norton farm was evident in the signs about planned development, as seen above. Restored by recent owners, the historic Norton house, shown below in the 1970s, reflects both old and new Potomac. (Above, courtesy of Larry McBryde; below, courtesy of M-NCPPC.)

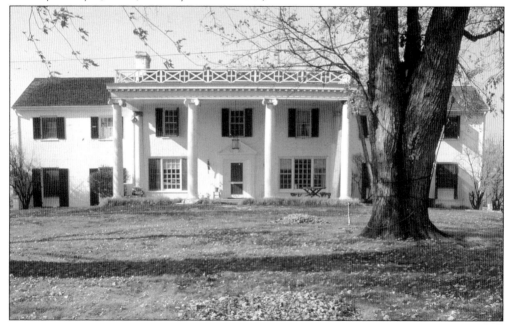

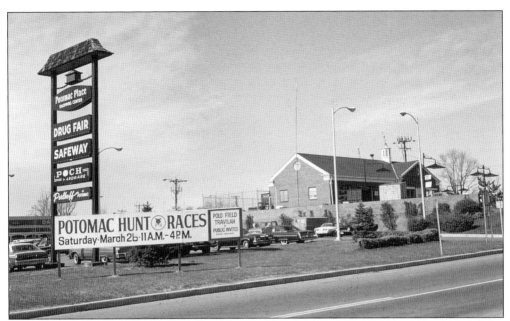

The Potomac Hunt Races began in 1936, making steeplechase racing an annual tradition with a break during World War II. Steeplechasing began in Ireland in the 18th century, where church steeples were often the highest landmarks. Horses and riders would race from a starting point to a church, jumping over ditches and fallen wood. In the 1960s, a banner in Potomac Village announced an upcoming race in nearby Travilah. The open fields where The Potomac Hunt could ride and race were disappearing. Construction of housing on the Poole farm, as an example, is shown below. In 2019, the Potomac Hunt Races were held at the Bittersweet Field on the Kiplinger estate in Poolesville. Race day still attracted crowds and included mounted police demonstrations, a car display, and fancy tailgates of sumptuous food. (Above, courtesy of Larry McBryde; below, courtesy of M-NCPPC.)

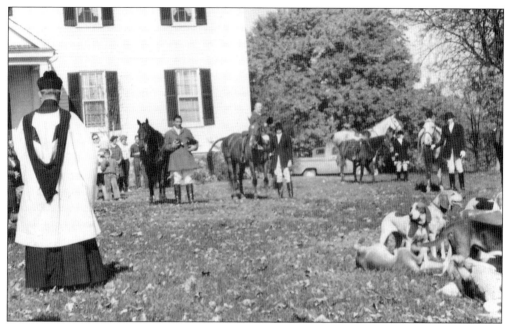

In 1964, the blessing of the hounds, pictured above, took place at The Potomac Hunt Club on Glen Road. Increasing development led the hunt to move beyond Potomac to near Barnesville in 1980. The Potomac Hunt continues today with traditional dress and etiquette. In the 1960s, members dressed in formal attire to attend and participate in the Washington International Horse Show (WIHS) at the Washington, DC, Armory (below). Among them were, standing from left to right, WIHS ringmaster Alice Keech, unidentified, US district court judge Richmond Keech, Lyn Carroll, Bill Carroll, and Ambassador Marion Smoak. (Below, courtesy of The Potomac Hunt.)

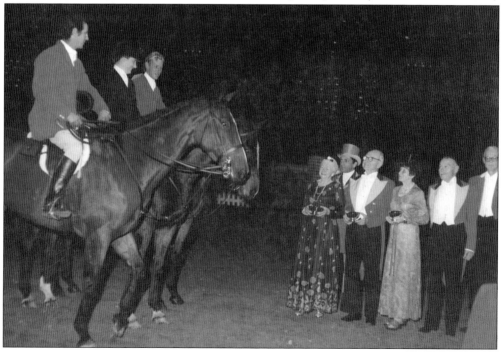

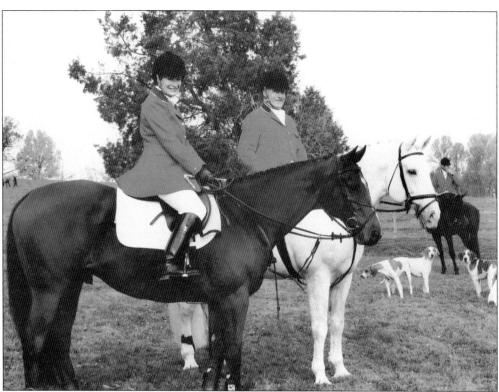

Prominent members of The Potomac Hunt have included Vicki and Skip Crawford, who have each been a master of the foxhounds, pictured above in 2010. The Crawfords lived in Potomac for 30 years and moved to Barnesville in 1989, where they raise foxhounds. They own Senior Senator, the horse that won the much-heralded Maryland Hunt Cup three times. At the 123rd running of this prestigious race in 2019, which Senior Senator won, they retired the trophy for the first time in 36 years. Lyn and Bill Carroll, a master of the foxhounds, are shown at right in 1968. F. Moran McConihe and Sam Bogley, who led the commercial development of Potomac Village in the 1960s, also were members and leaders of The Potomac Hunt. (Both, courtesy of The Potomac Hunt.)

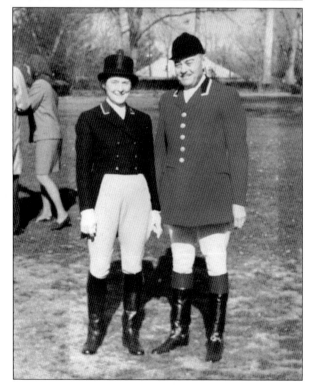

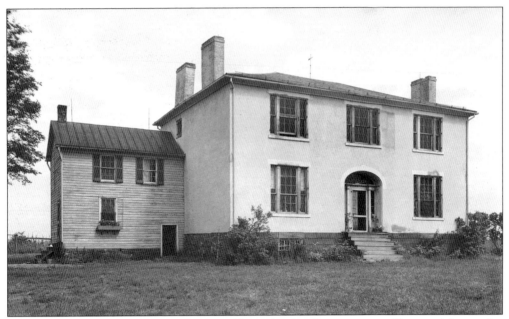

Publisher and journalist Austin Kiplinger and his wife, Mary Louise, acquired historic Montevideo in 1958. They restored the landmark and were among the first landowners in the county to put their land in Montgomery County's Agricultural Reserve. Montevideo, named for its view of Sugarloaf Mountain to the north, is a 400-acre farm established as a summer home in 1830 by John Parke Custis Peter, a great-grandson of Martha Washington. A burial plot predating the building contains the graves of the Peter family. The Potomac Hunt Race in May takes place on the western side of the property on the Bittersweet Field. The gathering for the annual Thanksgiving Day Hunt was at Montevideo in 2015, pictured below, and included Knight Kiplinger on the far right, Austin Kiplinger's son. Montevideo is pictured above in 1933. (Above, courtesy of Library of Congress; below, courtesy of Pat Michaels.)

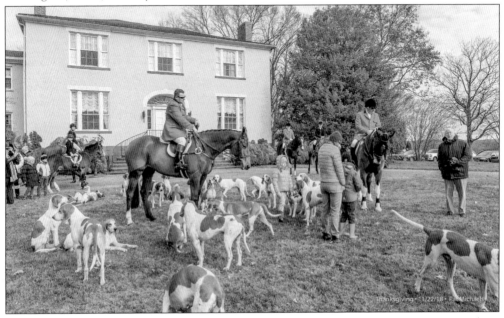

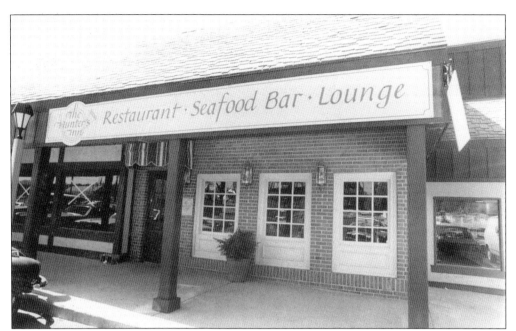

The Hunter's Inn, started by longtime Potomac residents, first opened in the Potomac Promenade shopping area in 1977 and moved across the street into the location of the DGS in 2002. Sometimes referred to as the Potomac's *Cheers* bar, the restaurant attracts both newcomers and familiar faces who find it a relaxed place to meet or, as once reported, "make a deal." The restaurant continues in the same location with restorations, a remodeled exterior, and in 2014, a change of name to Hunter's Bar and Grill. (Right, JW.)

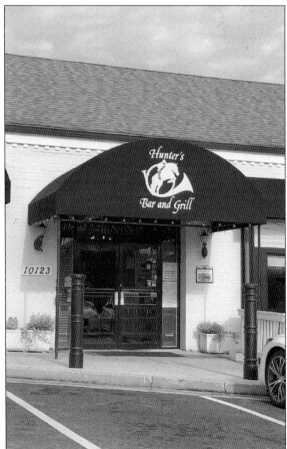

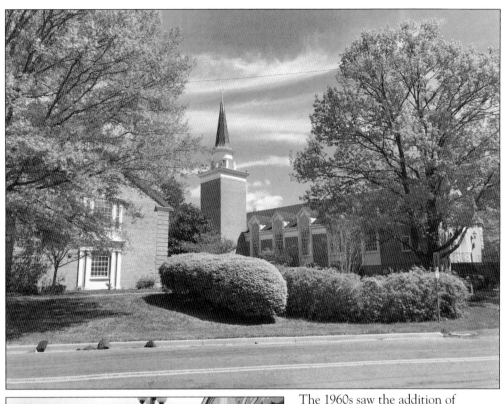

The 1960s saw the addition of new churches in Potomac to meet the spiritual needs of a growing population. St. Francis Episcopal Church, above, was dedicated in March 1962 on land donated by F. Moran McConihe. The year before, Archbishop Patrick O'Boyle dedicated Our Lady of Mercy Church. The Potomac Presbyterian Church opened its doors near the crossroads in March 1967, and on Christmas Eve 1969, Potomac Methodist Church held its first service in its newly built sanctuary. Population growth led to more stores in Potomac Village. The first supermarket opened in a large shopping center, Potomac Place, in 1967 opposite the smaller Potomac Village market place shops on the other side of River Road. A horse tether, like the replica now in Potomac, stood outside the drugstore that replaced the small pharmacy. (Both, JW.)

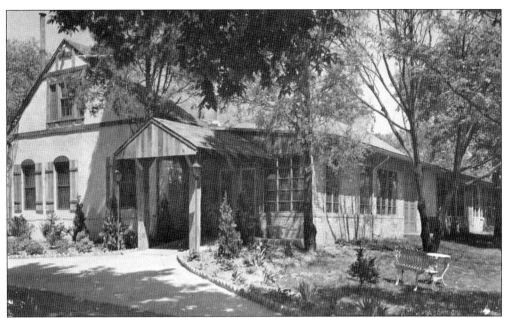

In 1931, Marjory Hendricks returned from cooking school in Normandy, France, and purchased Myers Farm to create her Normandie Farm Restaurant. She decorated the A-frame building in rustic French decor with scripted beams. One of the first customers was the Spanish ambassador, and others from Washington, DC, society soon followed. First Lady Eleanor Roosevelt came with her staff and enjoyed the restaurant's famous popovers. Hendricks closed Normandie Farm at the start of World War II when she joined the American Red Cross, serving in New Zealand, Austria, and Italy. She reopened Normandie Farm when she returned, and it became the restaurant of choice for society's elite and special occasions. In 1958, Hendricks sold Normandie Farm to the James Speros family. A postcard dated 1959, above, highlighted the restaurant, which is not very different from the restored building seen below. (Below, courtesy of Tim Shank.)

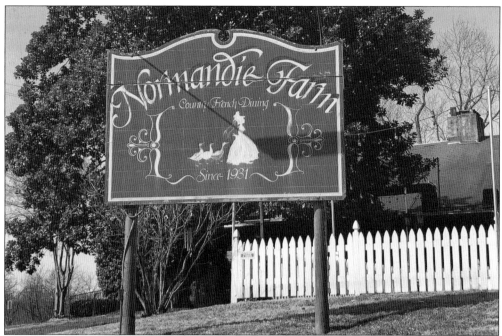

By 1979, Normandie Farm and approximately 50 acres were sold again and reopened in early 1982 after restoration. Owner and chef Cary Prokos and his wife, Margery, are continuing to enhance the restaurant's traditions. The beams of the main dining room are still scripted, and the fireplaces glow in the winter. A number of Potomac civic groups and organizations hold meetings at the restaurant. A group of residents who remember "old Potomac" gather at the restaurant for occasional luncheon reunions. (Both, JW.)

Old Angler's Inn, across from the C&O Canal and the Potomac River, takes its name from the Anglers Association that met in 1862. The building, constructed around 1910, housed the Cropley General Store and post office for locals, fishermen, and travelers on the C&O Canal. Workers at the Maryland Gold Mine frequented the general store when it was owned by Joe Bodine. Later, tourists traveling to Great Falls stopped to eat at Old Angler's Inn, as it became known. In the mid-1950s, John and Olympia Reges bought the restaurant. The structure remains as it has been, with some expansion and restoration by the same family and descendants who have owned it for more than 60 years. It is frequented by Potomac and area residents and bikers and hikers at the C&O Canal National Historical Park. (Above, courtesy of Tim Shank.)

The growth and development of the Potomac area during the 1960s brought the need for more fire protection. In 1967, the Cabin John Park Volunteer Fire Department, which had responded to calls from three miles away, placed an engine in a garage on the site of the present Potomac Veterinarian Hospital in Potomac Village. Volunteers bunked in an adjoining house donated by members of the community. In 1970, Station No. 30 opened at its present site at Falls Road. Today, in addition to fire prevention and suppression, Station No. 30 provides emergency medical services and swift-water river rescue services. (Above, courtesy of Tim Shank; below, photograph by Roy Sewall.)

The early years of World War II in the 1940s meant gas rationing and a ban on pleasure driving that brought back some horse-and-buggy transportation in Potomac. It also took many of the young men to war. Some who did not return are buried in the cemetery of the Potomac Methodist Church, including the grave of 18-year-old Benny H. Hunter, Navy seaman 2nd class, who was assigned to the USS *Comet* and died in action. The community hall near Great Falls became the Veterans of Foreign Wars (VFW) center. Veterans from Vietnam and the wars of recent years gather for events at the VFW center, pictured below. (Both, courtesy of Tim Shank.)

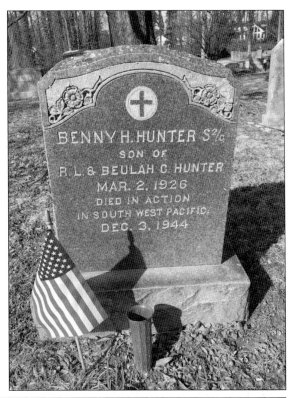

No story about Potomac would be complete without mention of the celebrities who made the area their home. Lynda Carter (Wonder Woman) married and raised her children in Potomac, as did former child star and ambassador Shirley Temple Black. Carter is seen above with young children at a class. Eunice Kennedy Shriver and Sargent Shriver and astronaut John Glenn and his wife, Annie, had homes in Potomac. Proximity to Washington, DC, meant that many well-known journalists, such as David Brinkley, Drew Pearson, Ted Koppel, and Wolf Blitzer; politicians; and diplomats lived in Potomac, and many still do. Sugar Ray Leonard, who was boxing world champion in several weight divisions, and heavyweight champion Mike Tyson lived in Potomac. At left, Al Dunham shows off Sugar Ray's bike, which had come in for service and repair.

Six

COMMUNITY LIFE

Potomac has always been a place for an active and outdoor life. Walking, hiking, biking, trail riding, or kayaking and canoeing are popular pursuits of individuals and families at the nearby Potomac River or the Chesapeake & Ohio Canal National Historical Park. Potomac residents come together for the annual Potomac Day Parade in October. The West Montgomery County Citizens Association, which started in Potomac, meets regularly to discuss environmental and development issues. A theater group of volunteers once entertained in professional-quality plays. Volunteerism and civic pride continue to engage the time and talent of Potomac residents in supporting and contributing to activities in the community and the nearby national historical park. Horses are still part of the picture in Potomac for those who want a trail ride. Horseback riders are seen in the Potomac Day Parade and when the National Park Service or county police patrol the trails and countryside.

The Potomac Day Parade is an annual event sponsored by the Potomac Chamber of Commerce. Elie Pisarra Cain, a community leader, organized the first parade in 1980 and championed it year after year. Maryland state troopers often lead the parade on horseback carrying the American and Maryland flags, followed by high school bands, Scouts, and other community groups. Below, in 2015, members of the Potomac Bridle and Hiking Trails Association (PBHTA) marched in the parade, with Samantha and Olivia Silins holding the banner and, from left to right on horseback, copresident Naomi Manders, Frederica Johnson, and Sheila O'Donnell. Potomac Polo Club riders in blue rode at the rear of the group. Harry Semmes Jr. formed the Potomac Bridle Trails Association in 1962 for horseback riders, and hiking was added in the 1980s. The group works to preserve equestrian trails. (Below, courtesy of Pam Dubois, past PBHTA president.)

The Potomac Chamber of Commerce was established in 1969, and members form the core of Potomac business. The chamber seeks to improve the business climate for the betterment of the community and recognizes business, civic, and youth leaders with annual awards. On Potomac Day, the chamber holds a business fair and classic car show after the annual parade. The board of directors, pictured above in 2019, included, from left to right, Vice Pres. Fred Goldman, secretary Andrea Alderdice, treasurer Steve Ornstein, board member Jill Phillips, and Pres. Adam Greenberg. By 1990, the Potomac crossroads had busy shopping centers on three of the corners, as seen in the aerial photograph below, with more than a handful of banks, restaurants, and seafood markets. (Above, courtesy of Potomac Chamber of Commerce.)

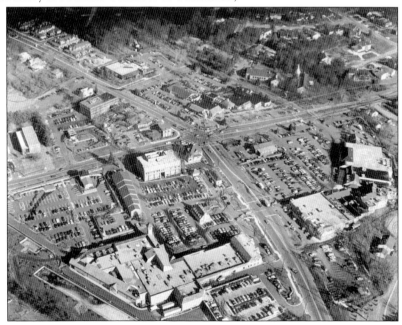

The Bogley family established and named Potomac Place, a major shopping area built in 1967 on what had been a community baseball field. Potomac Place has expanded since its beginnings with small shops, bistros, and an ice cream store in addition to the major grocery store that was there at the start. The courtyard, above, provides a peaceful area where shoppers and visitors can relax and eat outside in good weather from one of several restaurants. Potomac Village continues to be friendly and quiet, and as one resident commented, is "where shop owners and bank tellers know your face." Potomac Promenade is the other multistore shopping area in Potomac Village with another grocery store, banks, shops, and Potomac Pizza, which opened in 1978. During the annual Potomac Day, a community fair takes place in the parking area. (Both, JW.)

The Potomac Rotary Club holds breakfast meetings at a restaurant in Park Potomac, a few miles beyond Potomac Village. Above, Barton Goldenberg, Rotary District No. 26 governor, inducts US congressman David Trone, a businessman who represents the district including Potomac, into the Potomac Rotary Club in 2019. Anila Khetarpal, his sponsor, attaches his membership pin. Also pictured are, from left to right, members Asok Moytayed, Dr. John Sever, and Potomac Rotary Club president Chris Good. Longtime member Dr. Sever, a retired pediatrician and former chief of infectious diseases at the National Institutes of Health, initiated the Rotary's international effort to eradicate polio in 1985. Because of his contributions to eliminating polio throughout the world, the Potomac Chamber of Commerce named him Citizen of the Year in 2017. Below, he and his wife, Gerane, ride in the Potomac Day Parade. (Both, courtesy of the Potomac Rotary Club.)

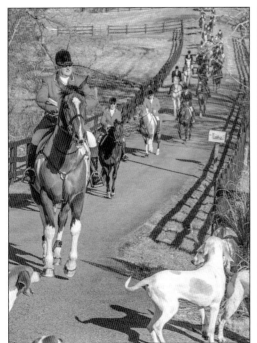

Although The Potomac Hunt no longer holds events within Potomac, residents who are members continue to ride with the hunt in upper Montgomery County and participate in hunt race activities in Poolesville at the Bittersweet Field at the Kiplinger estate. The continuing popularity of The Potomac Hunt draws not only riders but throngs of spectators to their events. Some Potomac residents also continue to own horses and stables. Signs warning drivers to be aware of riders on horseback appear on several Potomac roads, including the one above on Persimmon Tree Road near Potomac Village. (Above left, courtesy of Pat Michaels; above right and below, courtesy of JW.)

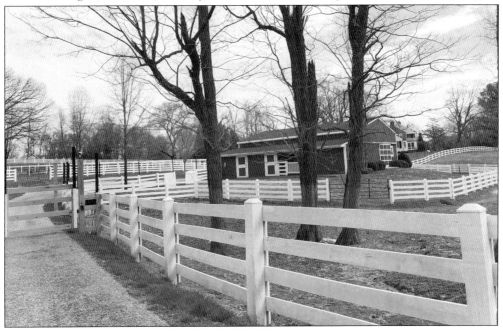

After canal operations ended after the floods of 1924, pleasure boats used parts of the repaired canal until 1936, when another major flood occurred. At that time, the federal government stepped in with the Civilian Conservation Corps and Works Progress Administration to help repair locks and lockhouses damaged by the rushing Potomac River. Storms today, such as Hurricane Agnes in 1972, can still cause flooding and damage along the canal. (Both, courtesy of Chesapeake & Ohio Canal National Historical Park.)

Golf continues to be popular in Potomac. The first public Montgomery County golf course, Falls Road Golf Course (above), opened on Falls Road in 1961 on 150 acres of former farmland. The 6,100-yard course was completely renovated in 2003 to include a new clubhouse and lighted driving range. A private golf club, TPC Potomac at Avenel, sits on 220 acres and has hosted the PGA Tour. Congressional Country Club (below), a private course, also hosts championship golf; it backs up to Persimmon Tree Road in Potomac but has a Bethesda address at its entrance on River Road. Tiger Woods and other golf celebrities have played at both courses. American presidents Calvin Coolidge, Dwight Eisenhower, Warren Harding, Herbert Hoover, William Howard Taft, and Woodrow Wilson were members of Congressional Country Club. (Both, JW.)

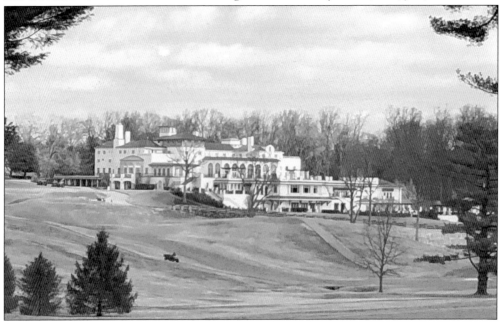

Just past the golf course is the Potomac Community Center, operated by Montgomery County, which offers a variety of recreational activities and programs for children and adults. The commemorative plaque for those who served in the armed forces was provided by the Little Farms Garden Club of Potomac. Little Farms Garden Club was established in 1961 at a time when farms were changing and new residents were coming to the area. The club continues to flourish, and every Christmas, members decorate the Great Falls Tavern with greenery and ribbon donated by local businesses. (Both, JW.)

A new cultural institution came to Potomac in 2006 with the development of Glenstone, a museum of modern and contemporary art developed by philanthropists Emily and Mitch Rales on nearly 300 acres of rolling pasture and unspoiled woodland. The museum's buildings, called pavilions, are integrated into the open space. Walking paths, above, take visitors across the fields and through the natural environment to the pavilions for iconic works of modern art and architecture and to outdoor installations of sculptured works. The museum is free to the public at scheduled times. The peaceful interior water court, below, is inside one of the pavilions. (Both photographs by Iwan Baan, courtesy of Glenstone Museum.)

In addition to significant estate homes, Potomac includes architecturally distinct buildings. The Art Deco–style Bolger Conference Center, above, was once a convent, a school for disabled children, and a training center for postal workers. Today, it is a 431-room conference hotel on 43 acres of Potomac countryside. The building, built in the 1930s, includes a ballroom with stained-glass windows. It is named for William F. Bolger, the 65th postmaster general from 1978 to 1985 and includes a Smithsonian postal exhibit with memorabilia dating to the Pony Express. Park Potomac is a planned community built in 2005 with brownstone town homes and condos next to restaurants, medical offices, and shopping. One of the apartment buildings is called the Perry, which relates to the historic Perry House and Perry Store buildings in Potomac Village. (Above, courtesy of Tim Shank; below, JW.)

West Montgomery County Citizens Association (WMCCA) began in June 1947, and founders included prominent Potomac names such as Clagett, Garrett, Counselman, McConihe, and Beale. It is the oldest civic association in the county and brings a reasoned voice to meetings and hearings on land use. WMCCA sees two-lane and rustic roads as integral to Potomac's semirural designation and also seeks to retain a village feel by holding the commercial footprint. Elected officials who represent Potomac, such as county council member Andrew Friedson, below, attend the civic group's meetings to discuss plans and seek feedback. Above, officers and board members in 2019 included, from left to right, (first row) Carol Van Dam, Ken Bawer, vice president; Jill Phillips, George Barnes, and Barbara Brown, secretary; (second row) Nancy Madden, newsletter editor; Susanne Lee, president elect; and Ginny Barnes, president. (Both, courtesy of WMCCA.)

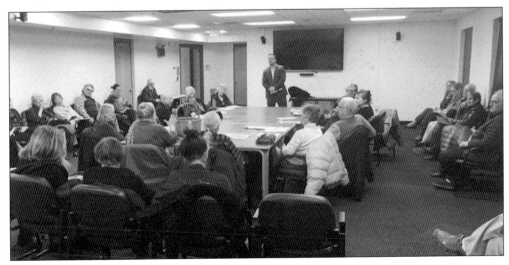

Potomac's first library began modestly in the 1960s in the basement of a bank next to Dunhams' Automotive. It moved to a new library building in 1985, constructed by Montgomery County as part of the public library system. Potomac's modern post office was built after a long history of postal services that began in Offutts X Roads Market in 1865. The post office moved across the street to Perry Store in 1885, and in 1914 moved out of Potomac to Rockville, which continued to deliver mail to Potomac residents. The post office eventually returned to Potomac in space in the rear of the Potomac pharmacy, and finally to a building all its own. (Both, JW.)

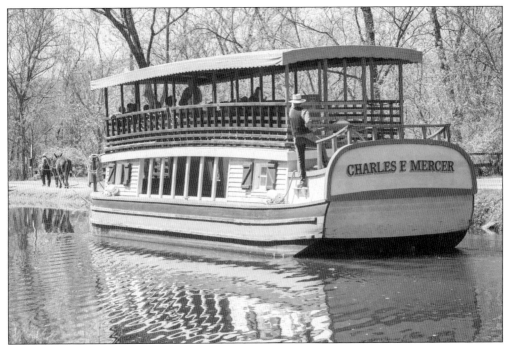

The Friends of Historic Great Falls Tavern led a two-year fundraising campaign to raise $545, 000 for a replica double-deck canal packet boat, the *Charles F. Mercer*, named for the first president of the C&O Canal Company. The boat gives park visitors the chance to experience what life was like on the Chesapeake & Ohio Canal. Don Harrison, president, pictured below with his wife, Elizabeth, spearheaded the effort that resulted in construction of a boat 57 feet long and 13 feet wide in 2006. Those dimensions allow the boat to go through the lock at Great Falls Tavern and also to turn around in the canal to return. Donations by Potomac residents, as well as a Maryland state grant, helped to acquire and now maintain the boat. (Above, photograph by Michael Mitchell; below, JW.)

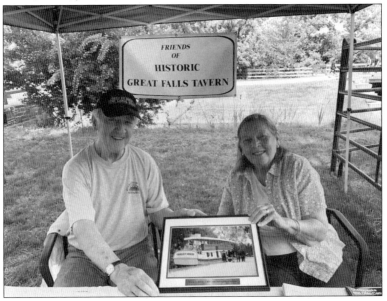

Potomac residents organized a village program as part of the nationwide movement to assist those who want to "age in place" in their homes. Potomac Community Village is a network of neighbors who help members with practical needs and activities so that people can reside in their homes as they age. Village activities include lectures, walks, lunches, and theater and museum trips. Above, a group walk on the Gold Mine Loop trail included, from left to right, Sheila Taylor, Barry Taylor, Scott Brown, Judy Chung, Sheila Moldover, Fung Lung Chung, Don Moldover, and Valen Brown. Volunteers also provide car rides to medical appointments or grocery stores for those who no longer drive. Below, in 2015, Potomac Community Village founders, from left to right, Owen Ritter, Leonard Cahan, Shirley Dominitz, Nelly Urbach, and Jane Blocher celebrate the third anniversary of the organization. (Both, courtesy of Potomac Community Village.)

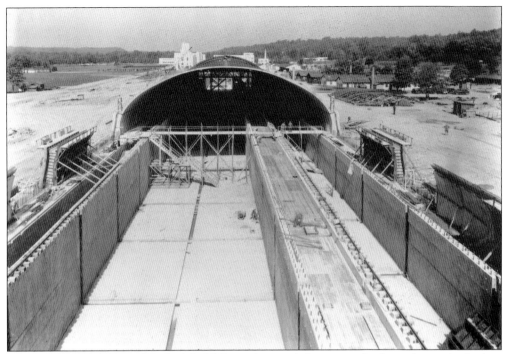

Construction of the David Taylor Model Basin for naval ship research, above, began in the late 1930s in the nearby area known as Carderock. The ship testing facility included a deepwater covered basin that was 1,188 feet long and 110 feet wide. More than 1,000 civilian and military employees worked at the model basin during World War II. The site was chosen because the bedrock provided a firm aligned foundation for the water testing and construction, with heavy steel rails leveled to match the curvature of the earth. Testing of a Coast Guard prototype vessel in the 1980s is shown below. The David Taylor Model Basin is now part of the Carderock Division of the Naval Surface Warfare Center in Potomac.

Much has changed in Potomac, but some things stay the same, including houses close to Potomac Village along Falls Road, shown above. These houses were built in the 1920s from a kit of house parts ordered from the Sears catalogue, delivered by train and trucks, and constructed by homeowners and local helpers. The same Sears houses pictured here in 1976 remain in 2019 with the only differences being in exterior paint and fewer trees. At right, like a reminder of the past, this vintage pay phone remains mounted across the street from the Sears houses, waiting for the next caller but no longer operating. (Above, courtesy of Larry McBryde; right, JW.)

Carved on the stone wall at the corner outside of the Perry House is the date 1880, which is the year the name Offutts Crossroads changed to Potomac. The Perry House stands prominently at one corner of the crossroads in Potomac Village, a symbol not only of the past but marking current times with every new occupant. The house was built on 21 acres of land and took about a year to complete. Other buildings now appear nearby on the property. In 1922, the Perrys sold the house and eight acres to a cousin. Since then, the structure has been used for a series of businesses important to the commerce and growth of Potomac. (Above, courtesy of Ralph Buglass; below, JW.)

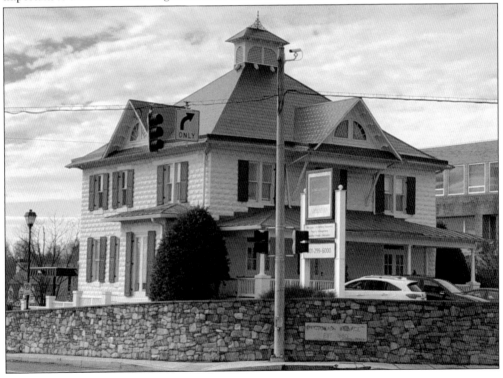

MONTGOMERY HISTORY

MONTGOMERY COUNTY HISTORICAL SOCIETY

Montgomery History, the historical society for Montgomery County, Maryland, has been serving the community since its founding in 1944. Its mission is to collect, preserve, interpret, and share the histories of all of Montgomery County's diverse residents and communities. It helps to build a vibrant and welcoming county by connecting those who are shaping the future with the stories of those who made the past. Montgomery History operates two museums at its Rockville campus: the c. 1815 Beall-Dawson Museum and the Stonestreet Museum of 19th-century medicine. It manages a collection of 11,000 historic artifacts, operates the Jane C. Sween Research Library and Montgomery County's government archives, provides a home for the county's genealogical society, brings scholarly and public attention to 20th-century history through the Harper Center for Suburban Studies, hosts an annual history conference, operates an award-winning Speakers Bureau, and offers numerous educational and community exhibits and events every year. For more information, visit www.MontgomeryHistory.org.